IMAGES
of America

COOKEVILLE AND
PUTNAM COUNTY

IMAGES
of America

COOKEVILLE AND PUTNAM COUNTY

Friends of the Cookeville History Museum

ARCADIA
PUBLISHING

Published by Arcadia Publishing
Charleston SC, Chicago IL, Portsmouth NH, San Francisco CA

Printed in the United States of America

Library of Congress Catalog Card Number: 2007942671

For all general information contact Arcadia Publishing at:
Telephone 843-853-2070
Fax 843-853-0044
E-mail sales@arcadiapublishing.com
For customer service and orders:
Toll-Free 1-888-313-2665

Visit us on the Internet at www.arcadiapublishing.com

*This small volume is dedicated to all Putnam Countians,
past, present, and future.*

CONTENTS

ACKNOWLEDGMENTS

Many people have contributed to this project in one degree or another. They are too numerous to mention, but their efforts have been duly noted. There are, however, a few individuals who, due to their willingness to go above and beyond the call of duty, deserve special mention. Most notably, Jim Bussell, Eunetta Jenkins, and Cathy Lamb worked tirelessly to see this project to fruition. This small volume could not have been completed without their help. Also of special note are H. S. Barnes, Sam Barnes, Alice Brown, Carolyn Brown, Chip Carlen, Hill Carlen, Dean Carothers, Bobby Davis, Judy Duke, Steve Johns, Mancil Johnson, Touch Lamb, John Limbacher, Deborah Heard Long, Bob Lowe, Monte Lowe, Charlene McClain, Laura Medley, Cecil Montgomery, Billy Shipley, Lucy Stanton, Davis Watts, Larry Whiteaker, Edie Williams, and Patsy Williams. We would also like to thank the Tennessee Tech archives, the Putnam County Library, the James Heard Collection, and the Cookeville History Museum. Your help has been much appreciated.

Unless otherwise noted, all images are from the Cookeville History Museum.

Disclaimer:
Every effort has been made to correctly identify individuals in photographs and to provide accurate information throughout this book. However, some names and information are lost to history. If we have failed in our efforts, please accept our sincere apologies.

INTRODUCTION

The story of Putnam County is a twice-told tale. First established on February 2, 1842, by an act of the 24th Tennessee General Assembly, Putnam County was formed from sections of Fentress, Jackson, Overton, and White Counties. Overton and Jackson Counties secured an injunction against Putnam County's continued operation due to the belief that the formation of Putnam County reduced their land area below constitutional limits. In March 1845, Putnam County was declared unconstitutionally established, and the county was dissolved. In 1854, the Tennessee State Legislature passed an amended bill, introduced by state senator Richard Fielding Cooke, which updated the original county boundaries, thus reestablishing Putnam County. The county was named in honor of Revolutionary War hero Gen. Israel Putnam; the county seat was named in honor of Senator Cooke.

Early settlers came into what is now Putnam County mainly by way of the Walton Road, which ran between Fort Southwest Point on the Clinch and Little Tennessee Rivers near present-day Kingston to the confluence of the Cumberland and Caney Fork Rivers near Carthage. In 1801, the Walton Road was the main road into what would become Putnam County.

Native Americans had maintained a presence in the Putnam County region for thousands of years, from the Paleo-Indian through Mississippian periods and into the historic period. The land of this region was used primarily as a communal hunting ground by a number of tribes, but the Cherokees were the dominant group of the region. Cherokee claims to the land that would become Putnam County impeded white settlement of the area until October 1805, when the Cherokee tribe signed the Third Treaty of Tellico, relinquishing claim to all lands of the Cumberland Plateau and Cumberland River Basin. It was after the signing of the Third Treaty of Tellico that white settlers started moving in substantial numbers into the Upper Cumberland area of Tennessee. Early settlements in Putnam County included Standing Stone, Mine Lick, White Plains, Double Springs, and Bloomington Springs.

Putnam County encompasses parts of three distinct physiographic regions: the Cumberland Plateau, the Eastern Highland Rim, and the Central Basin. All three of these regions are hilly to mountainous, highly dissected, and have many streams crossing them. Due to the rugged nature of the land, early settlers of the region were mainly subsistence farmers. Timber production was also an important component of the Putnam County economy in the 19th century.

The nature of the land also influenced slaveholding in antebellum Putnam County. The land and topography was not conducive to large-scale, labor-intensive agriculture; as a result of this, slave labor was very limited in Putnam County. When the Civil War came to Tennessee in 1861, Putnam Countians were divided in their loyalties. Men from Putnam County served in both the Confederate and Union Armies, and the area saw some of the most bitter and destructive partisan warfare of the entire Civil War.

Putnam County remained relatively isolated and insular in the post-war era until 1890, when the Nashville and Knoxville Railroad began service through the county. This was to be a pivotal event in the history of the region. The N&K was sold and became the Tennessee Central Railroad

in 1893. Putnam County was opened to the outside world, and new communities such as Algood, Baxter, Buffalo Valley, Brotherton, Boma, and Silver Point became established as a result of railroad service and industry throughout the county. The railroad opened Putnam County to new markets and ushered in an era of unprecedented growth. New industries such as textile manufacturing began operation in Putnam County; coal mining and large-scale timber production were direct results of the railroad's influence on the local economy. The railroads held sway over the transportation of the region until the construction of reliable, year-round highways.

The establishment of reliable highways through Putnam County further opened the region to outside markets and hastened economic development throughout the county. U.S. Highway 70 opened in 1930, and by the early 1960s, Interstate 40 was in operation in Putnam County. The coming of the highways allowed Putnam County to expand its economic base by adding new industries, a trend that continues today.

Cookeville has grown from a small, rural community into the position of hub city for the entire 14-county, 5,000-square-mile, Upper Cumberland region of Tennessee. The city has become a major retail center, the largest between Nashville and Knoxville, as well as a regional health care and educational center. Cookeville is one of the fastest growing areas in Tennessee and is consistently ranked as one of the top retirement areas in the nation. Cookeville is home to Tennessee Technological University and its 10,300 students. It is also the home of Nashville State Technical College. Tennessee Tech has been ranked as one of the South's best colleges, and its students consistently perform above the national average.

The story of the land that is now Putnam County is an ancient one, with native peoples flourishing upon the land for thousands of years and establishing their own culture in its forests and valleys. Europeans and Africans eventually arrived in the area; their story is one of pioneer settlement and the establishment of familiar institutions still in use today.

The future of Cookeville and Putnam County holds the prospect of increasing cultural diversity and opportunities for economic growth. Putnam Countians look to the future while maintaining the traditions of the past, making the county a desirable place to live, work, and raise a family. We invite you to come experience the beauty and hospitality of Cookeville and Putnam County for yourself.

—Randal D. Williams
Historic Preservation Planner
Upper Cumberland Development District
Cookeville, Tennessee

One

OLD COOKEVILLE
AND COMMUNITIES

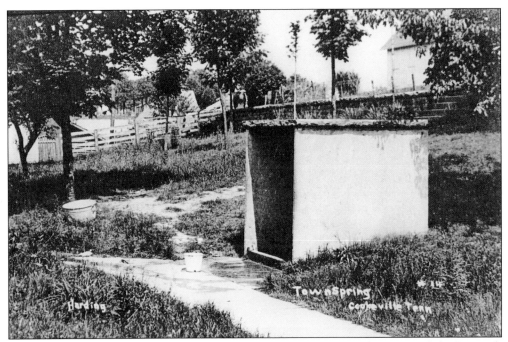

The town spring was located between the present Whitson Funeral Home and the Jeremiah Whitson home on North Dixie Avenue. Because of this spring, Cookeville was chosen as the county seat. It was also important because it supplied water to the community. The spring continued to be used by local people even after they installed wells. In the 1960s, the spring was covered with asphalt to connect a road to the new Kuhn's Big K in Midtown Plaza.

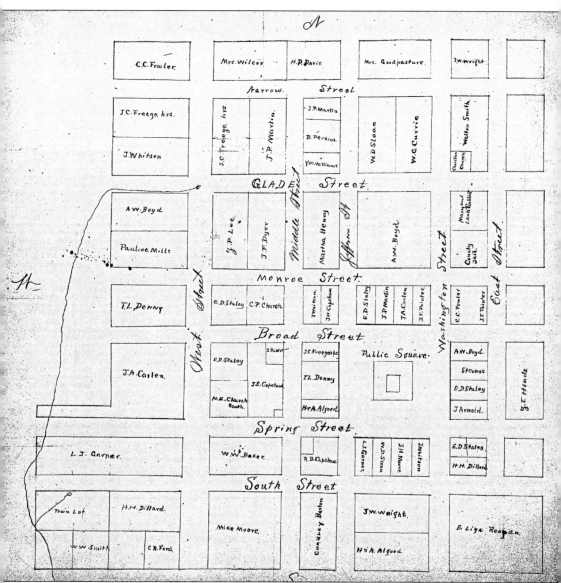

This very early map of Cookeville shows the town spring located on West Street, now Dixie Avenue, and the second town spring located on South Street, now Reagan Street. Many of the street names have changed. The map was found in a safe at Whitson Hardware Store. (Courtesy of Robert Lowe Jr.)

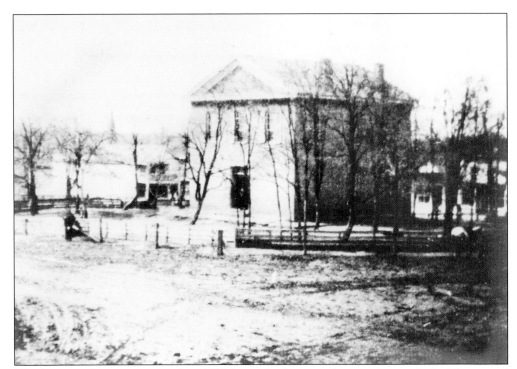

The first courthouse, completed in 1856, burned a few years later and was rebuilt. The second courthouse was burned accidentally by Union soldiers who camped there in 1861. Putnam County's third courthouse, pictured, was built in 1866 and burned in 1899. The present building was completed in 1900, and it was extensively remodeled in 1962, at which time the clock tower was removed.

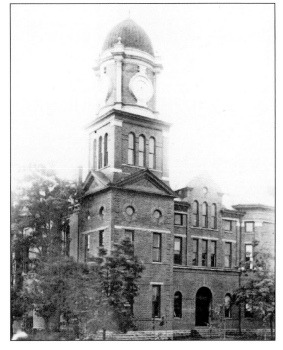

The fourth courthouse was completed in 1900 and cost $25,000 to build. The clock tower had a medieval appearance and was on the northwest corner of the building. The bricks were made at Scott Brick Kiln located at the present site of the Willow Tree Shopping Center. The tower was removed, and other changes were made when the courthouse was remodeled in 1962.

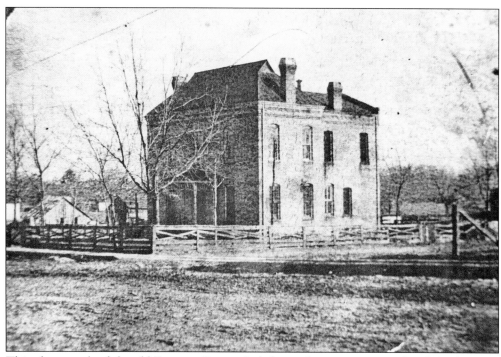

This photograph of the old Putnam County Jail shows the structure as it faced Washington Avenue in the area where the county court clerk's office is now located. Alex Weeks was sheriff at the old jail from 1908 to 1912. It was built around an even older jail believed to have been constructed in the 1800s.

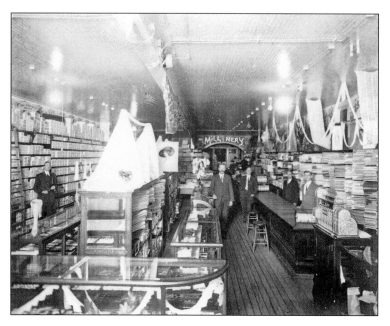

Shown in the interior of the Whitson Brothers store are W. L. Whitson, John H. Whitson, Jess Pendergrass, Cecil Elrod, and an unidentified man. Margie Goodpasture Jared operated the millinery department store. It was located on the corner of East Broad Street and North Washington Avenue.

Whitson Brothers was located on the Cookeville Square at the corner of East Broad Street and North Washington Avenue, where the law office of Will Roberson is now located.

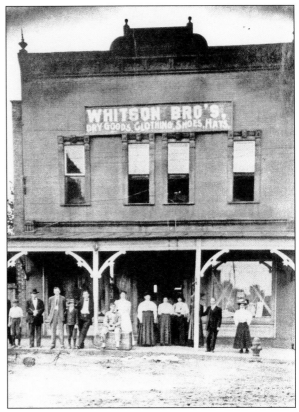

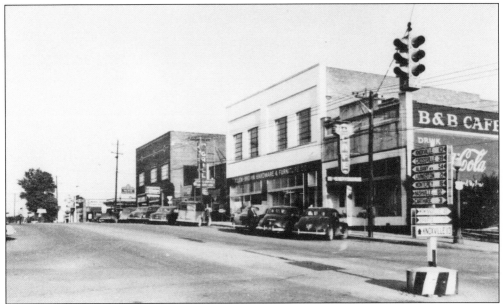

This street scene on the south side of the courthouse shows the B&B Restaurant located on the front corner of East Spring Street and South Jefferson Avenue. The Masonic Building is adjacent to the B&B, Gibson's Grill, and Vaughn's Grill, and Maddux Hardware is located at the end of the block on the right. Note the directional signs in the center of the street.

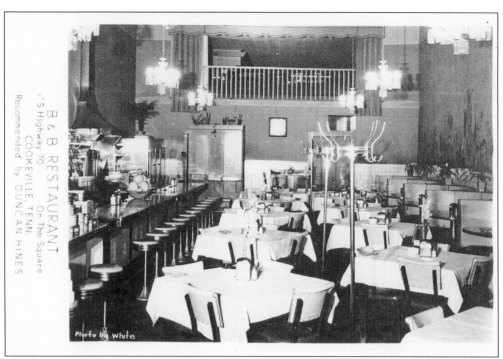

This is the interior of the B&B Restaurant, which was owned and operated by Pack Fox in the early 1950s. It was located on the corner of East Spring Street and South Jefferson Avenue.

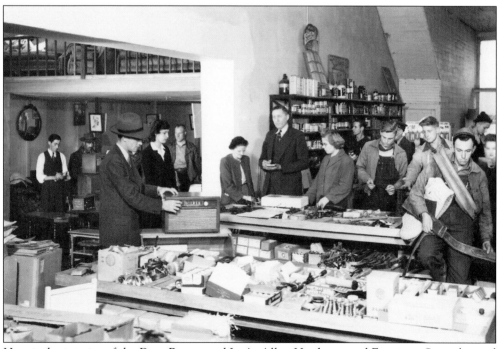

Here is the interior of the Dero Brown and L. A. Allen Hardware and Furniture Store, located on the south side of the square adjacent to Maddux Hardware Store.

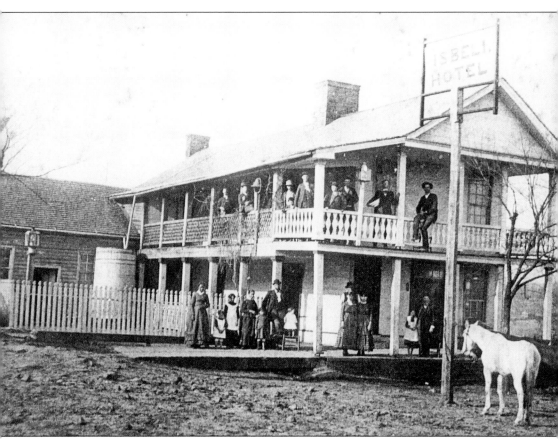

The Isbell Hotel was the first hotel in Cookeville. This is a picture of the hotel in 1886, when it was owned by the William J. Isbell family. It was located on the south side of the courthouse square. William Isbell, who operated the hotel, was a Putnam County trustee and county court clerk for several years. The identified people in this photograph are, from left to right, (standing on lower porch) "Aunt Ranie," Hattie Isbell, Mary Ann Isbell, Mrs. Amanda, Helen Starnes Isbell, Dora Isbell, William Jefferson Isbell, Myrtle Isbell, Safronia Jones, Nancy Melvina Isbell, Lillie Martin Isbell, and Anderson Sloan; (top row) second from right, holding a washbowl, is Fate Isbell, and third from the right is Ferrell Stames.

This photograph is of Carlen's Grocery Store, which was located on the north side of the courthouse in the early 1900s.

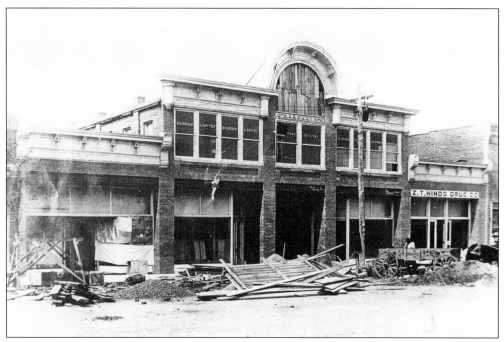

This is the scene at the original construction of the Arcade Building, a Cookeville landmark that stands on the west side of the courthouse square. In 1913, the building was ready for occupancy by lawyer B. G. Adcock, dentist G. N. Gurthrie, and others. It is listed in the National Register of Historical Places. Note the horse-drawn wagon parked in front of the building on the right.

Pictured is the interior of the Arcade Building. Note the Joe F. Dyer Realty Company and Insurance sign and the beautiful skylight. Charlie Gibson, who also had an office there, built the Arcade. There were law offices, a doctor's office, a clothing store, and a printing company to name a few. The Arcade remains as an office building to this day.

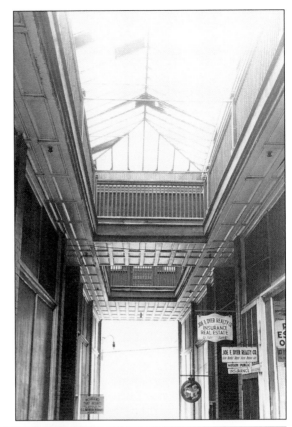

Buford Smith, Claude Wilmoth, and Herbert Whitaker operated the Arcade Barbershop. Pictured here are Buford Smith (left) and J. D. Mackie.

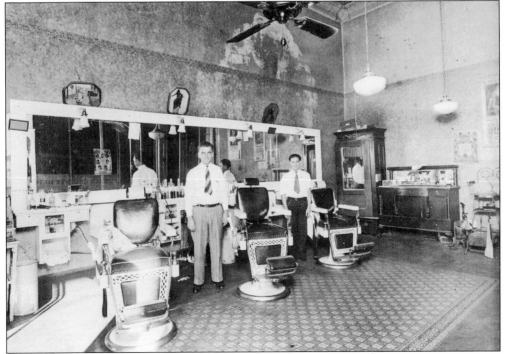

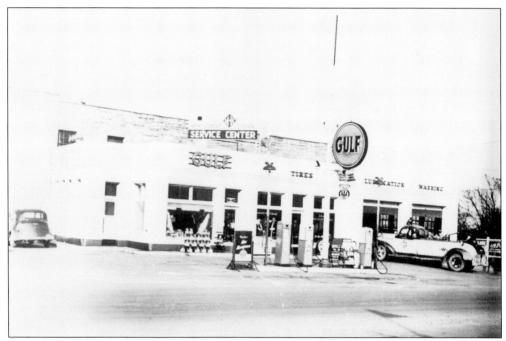

This Gulf Service Station was located at one of the busiest intersections in Cookeville: the corner of West Spring Street and North Washington Avenue. In the early 1900s, it was identified as the Montgomery-Horn Gulf Service Station. This was a very popular location well into the 1960s after Interstate I-40 opened. The Dunn family operated this station for more than three decades. Dunn's Gulf did not close until the mid-1990s.

This street scene is viewed from what was Terry Brothers Department Store and is now the Lamp and Lighthouse, located on the corner of West Broad Street and North Washington Avenue looking east toward Buck Mountain Road. In the middle of the background on the right is what was once the old Howard Hospital that is now being used as an office building.

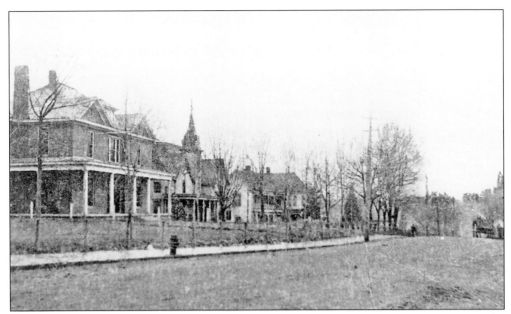

This view on East Broad Street shows the houses that once stood where the drama center, the Cookeville History Museum, and the Putnam County Library are now located. The Sid Jenkins house is on the left; next is Dr. Henry Martin's house and then the Capshaw house.

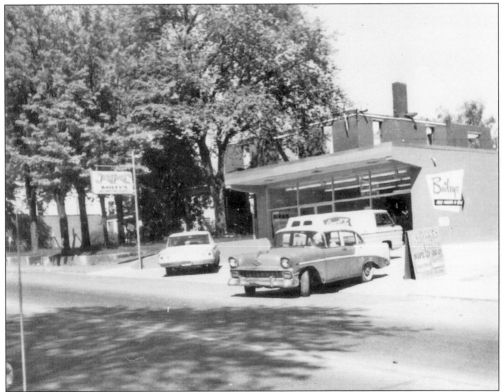

The present building of the Cookeville History Museum, located on East Broad Street, was constructed by Jasper Bailey Jr. to be a paint store named Bailey's Color Magic.

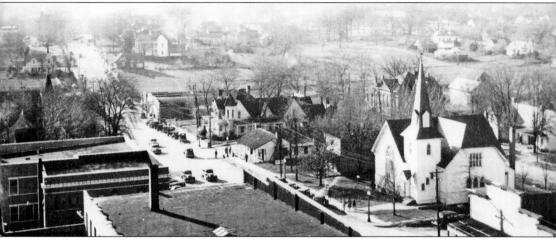

This street scene from Broad Street looking west from the square shows Cumberland Presbyterian Church at the front right, which was torn down and replaced with a new building on East Tenth Street. Next to the church was the Putnam County Health Department, which later became the Putnam County Library and then Jack Sells Drug Store. The site is now where the First United Methodist Church Christian Life Center is located. The James Carlen house, later torn down, is on the corner, and Carlen Motors is next door. In the space beyond Carlen Motors is where the Putnam County Library is now located.

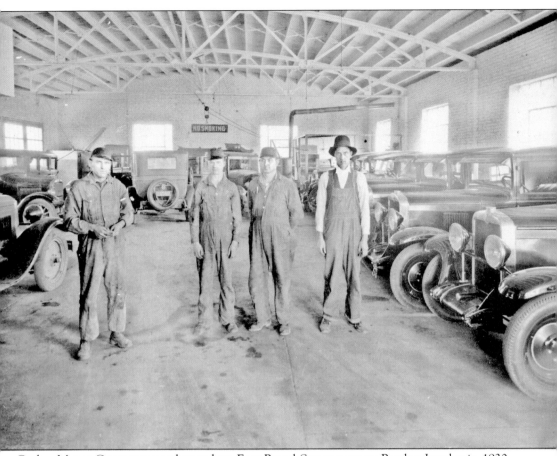

Carlen Motor Company was located on East Broad Street next to Borden Jewelry in 1930. Taylor Rhea owned the motor company first and sold it to Benton Carlen in 1927. Carlen Motor Company is still in business, located on West Spring Street. Pictured from left to right are Taylor Rhea, mechanic and salesperson; Howard Holloway; and mechanics Ham Williams and Rube Maynard.

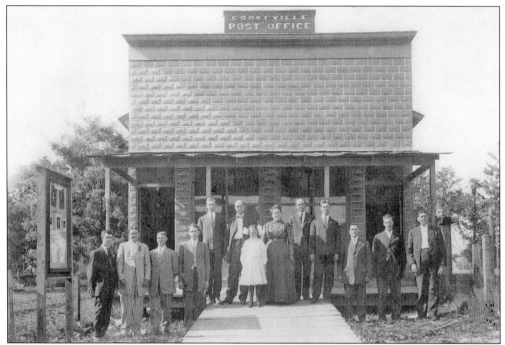

This is one of the oldest known post office buildings in early Cookeville, located at East Broad Street where the First United Methodist Christian Life Center location is now. Bynum Greenwood is standing fifth from the left and is the only person identified in the photograph.

Shown here is the Doctors' Building in about 1938. In the early days, this building was occupied by the offices of several local doctors, including Dr. J. P. Terry, Dr. W. A. Howard, and Dr. Harlan Taylor. It is located on East Broad Street. In addition, Williams Florist was located in the building on the right. On the left was the General Telephone Company building, which today is occupied by the Frontier Telephone Company. Behind the telephone company going south to Spring Street was the bowling alley.

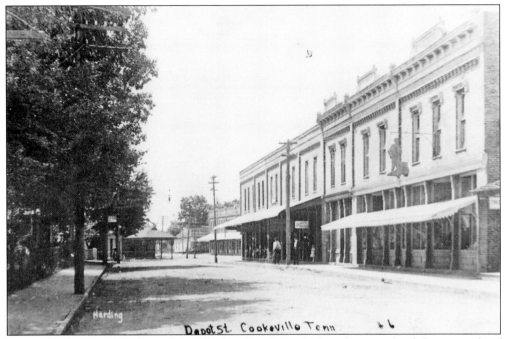

Mr. Richard Henry Harding of the Harding Studio took this photograph of the west side of Cookeville showing the buildings on a quiet afternoon in the early 1900s. Notice the dirt road and the trees built into the sidewalk on the left. The depot can be seen in the distance.

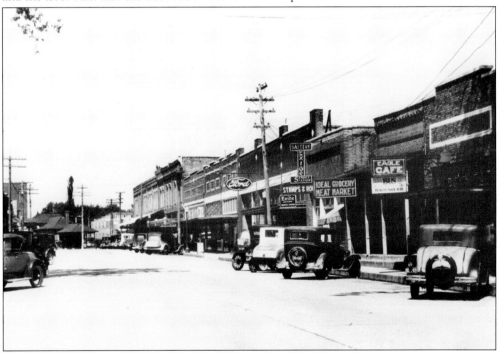

This street scene on the west side of Cookeville was taken later with the bus station located between Eagle Café and Ideal Grocery and Meat. On the other side of the bus station is Ford Motor Company. Notice the difference between the two pictures.

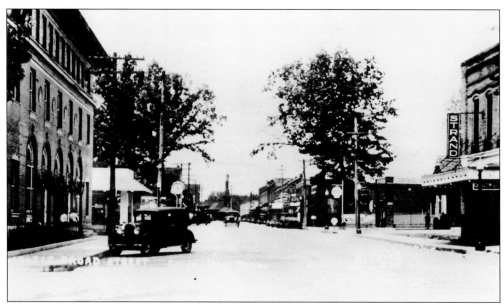

This 1930s street scene of West Broad Street shows the Strand Theater on the right; on the left is the present Cookeville Post Office and Federal Court Building. At the very far end of the street is the Cookeville Depot.

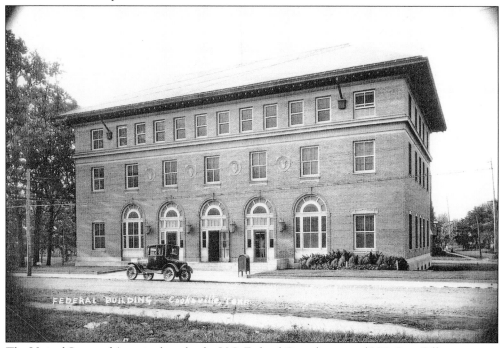

The United States of America bought the U.S. Federal Courthouse and U.S. Post Office property in August 1911 from Jesse Elrod and his wife, Willie Elrod, for a new Cookeville Post Office on the corner of Broad Street and Walnut Avenue. This same post office building still stands on this site today. The Cookeville Post Office was established August 23, 1855. An "e" was added to "Cookeville" on December 4, 1896, making it the Cookeville Post Office. The first postmaster was Curtis Mills.

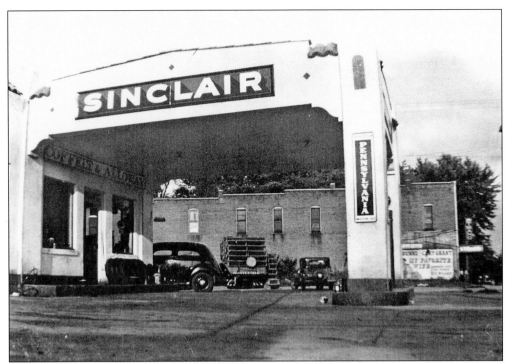

This Sinclair Station was located on the northwest corner of Broad Street and Walnut Avenue where the Cookeville Drama Center is now located. The Strand Theater is pictured in the background.

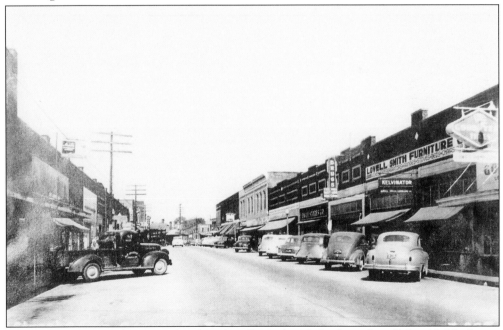

This street scene on the west side of Cookeville in the 1940s shows Lovell Smith's Hardware, located next to West Side Drug Store, owned and operated by Cecil Davis and later by his son Bobby Davis. At the end of the street is the Cookeville Depot.

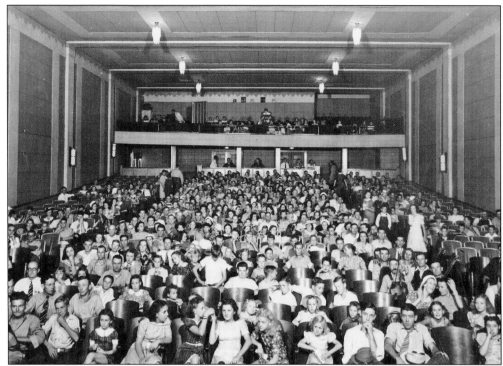

This is a picture of a weekend crowd at the Princess Theater. It was the place to meet friends and watch a movie. The lobby had a popcorn machine, soft-drink dispenser, and glass cabinets displaying candy. Occasionally the theater was used for cultural events.

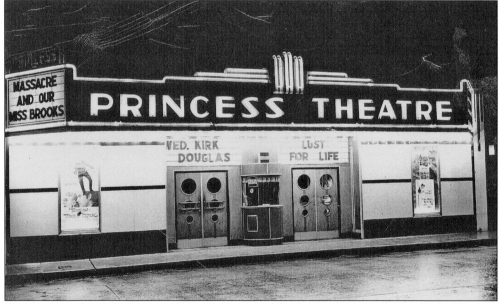

This photograph of the Princess Theater taken at night depicts the architecture and lighting of this favorite Cookeville venue. Stacy Wilhite, Hugh Hargis, and Edwin C. Reeves opened the doors to the public in 1935. Leon DeLozier bought the Princess in 1961 and operated it for almost 20 years. It was located at the corner of West Broad Street and Church Avenue.

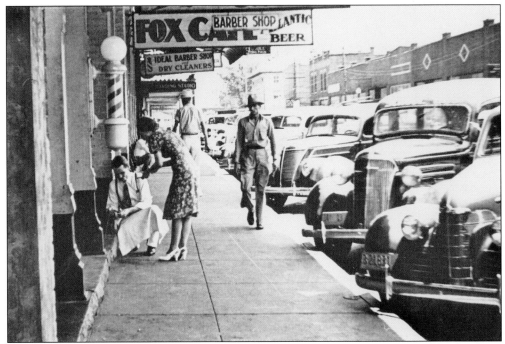

Pictured here in the late 1930s is the Fox Café on the west side. Standing by the barber pole is Hugo Fox (left) and Edith Fox. The other people are unidentified.

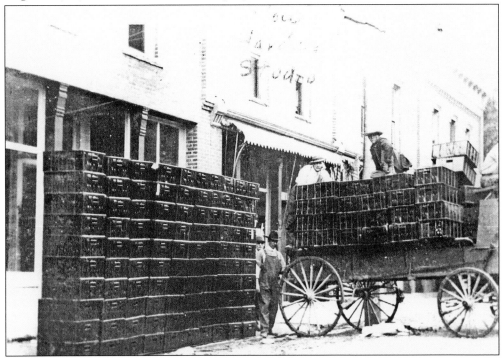

This photograph taken in the early 1900s shows workers unloading soft-drink crates. In the background are the bottling works, Peoples Bank that was once Harding Studio, and Jenkins and Darwin's Store.

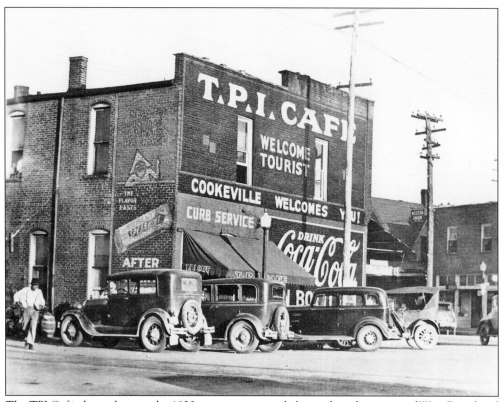

The TPI Café, shown here in the 1930s, was conveniently located on the corner of West Broad and Cedar Streets. It was located across from the Cookeville Depot and was a very popular café.

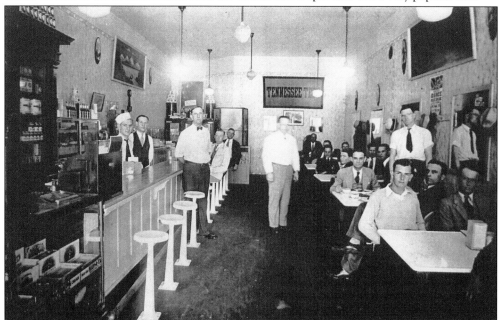

This photograph is of the interior of the TPI Café owned by Pack Fox. Behind the counter are Pack Fox (left) and his brother Lloyd Fox. The other people in the photograph are unidentified.

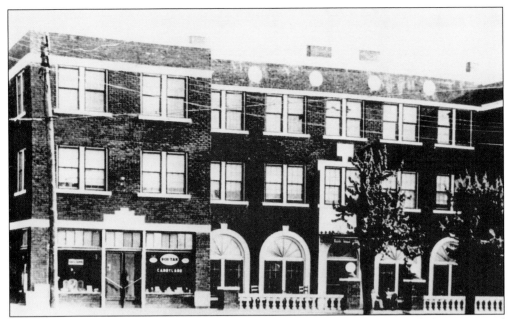

The Shanks Hotel opened in 1926. Mr. and Mrs. H. F. Shanks bought the Duke House and updated, remodeled, and added on to the old hotel. It was the largest hotel in the county, with 50 rooms and 60 beds. The dining room was large, and the Sunday noon crowd enjoyed live music. There were stores on the bottom floor.

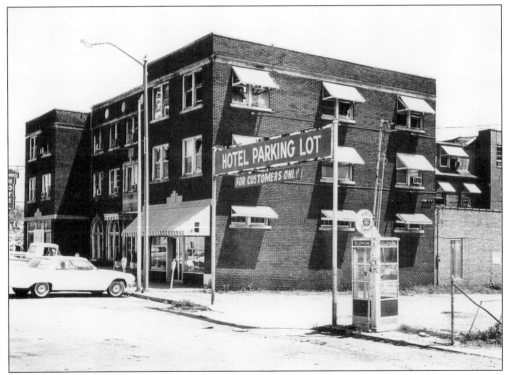

This is another picture of the Shanks Hotel, located on the west side of Cookeville across from the Cookeville Depot. It was destroyed by fire in 1968.

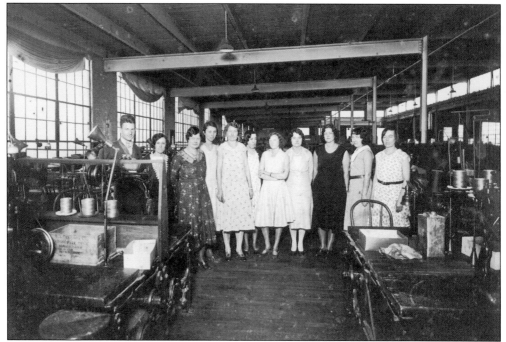

Menzie Shoe Company opened in Cookeville in 1926 where Broad and Cedar Streets intersect. The plant at one time employed 150 people and survived the Depression. The most popular shoe was sold at a very low price. It was the D K model and cost 11¢ to make. The employees pictured are, from left to right, William Scott, Gladys Scott, Lillie Wright, Grace Gallahey, Maude Thompson, Agnes Dillard, Johnnie Grimes, Bessie Howell, unidentified, Kate Fox, and Mattie Lacy.

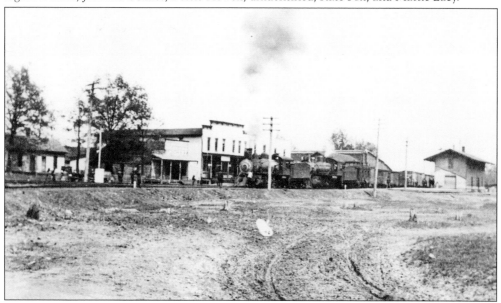

Pictured is the first Cookeville Depot building on the right in 1907. The depot was replaced in 1909 by another building, and today it is the Cookeville Depot Museum. The P. M. Smith building is to the left of the depot and was destroyed by fire. Buildings were constructed later and farther back from the railroad tracks. These buildings are still in operation.

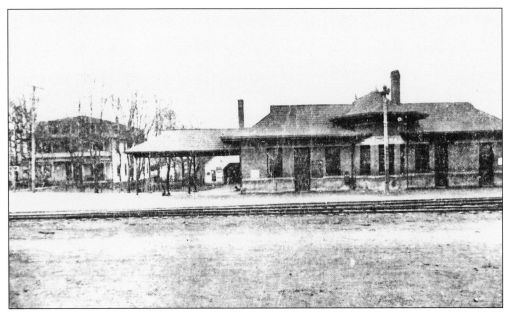

The construction of the Cookeville Depot building began in 1909 and was completed in 1910. It is now open as the Cookeville Depot Museum in the original building. In the background are the Duke House Hotel and the John C. Wall Livery stable, which is the current location of the parking lot of the depot museum. The livery stable building was demolished. The Duke Hotel was across from the depot and was later refurbished to become the Shanks Hotel.

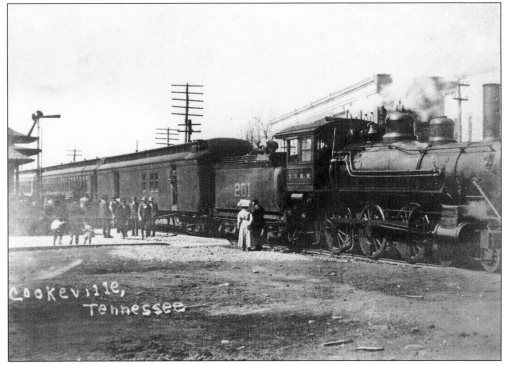

Pictured are passengers waiting to board the train at the Cookeville Depot around 1910. The Tennessee Central Railroad arrived in Cookeville in 1890; passenger service ceased in the 1970s.

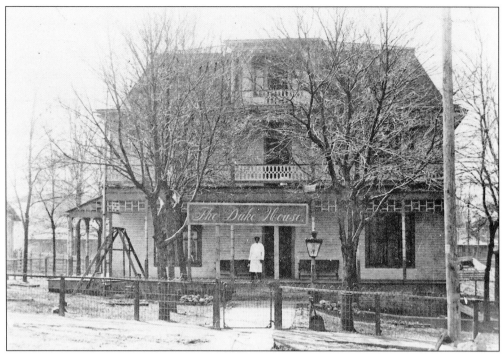

The Duke House was located across from the Cookeville Depot on what is now the Wilson Sporting Goods parking lot. It was an ornate three-story public house where, in earlier days, a waiter would walk to the porch when the train came in and ring a dinner bell. Railroad travelers would often spend the night here. Later it became the Shanks Hotel.

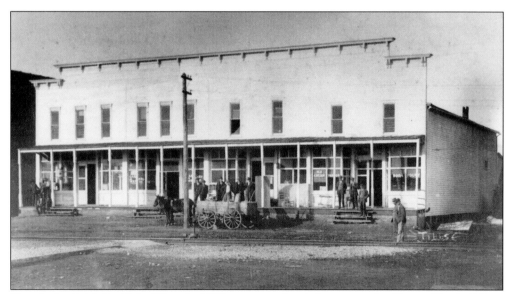

Here is the P. M. Smith building in 1900, next to what is known as the Cream City building, which is across the street from the Cookeville Depot Museum. The buildings destroyed by fire were replaced by the structures standing today. The Cookeville Citizens Bank was on the right-hand corner with Pendergrass Hardware next door. (Courtesy of Cecil Montgomery.)

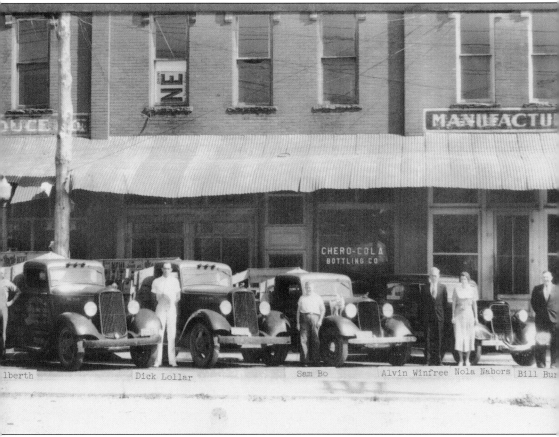

Pictured in 1935 is the Chero-Cola Bottling Company on West Broad Street across from the Cookeville Depot. Pictured from left to right are Bill Gilbreth, Dick Lollar, Sam Bo, Alvin Winfree, Nola Nabors, and Bill Burris.

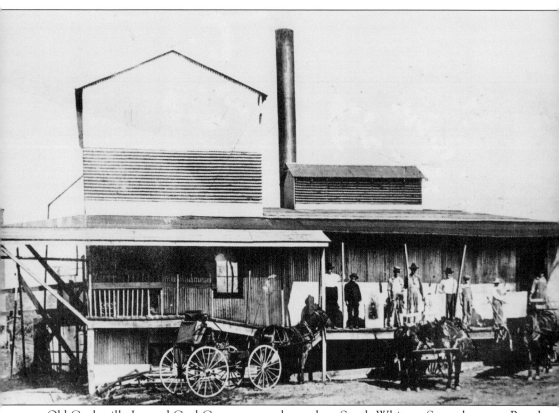

Old Cookeville Ice and Coal Company was located on South Whitney Street between Broad Street and the Tennessee Central Railroad. Hugh Hargis and Algood Carlen owned it in the 1920s and 1930s. The Tennessee Central Railroad shipped most of the coal, so this was an excellent location. The ice plant burned around 1938, and a new building was erected. It burned again in the late 1950s and was never rebuilt.

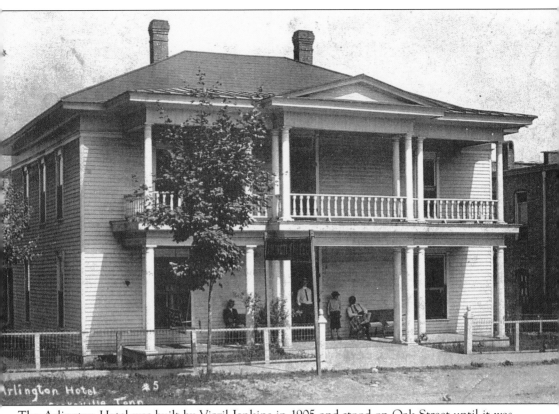

The Arlington Hotel was built by Virgil Jenkins in 1905 and stood on Oak Street until it was destroyed by fire in 1968. The story goes that Jenkins traded the hotel to P. G. Cooper for a patent on a mechanical churn.

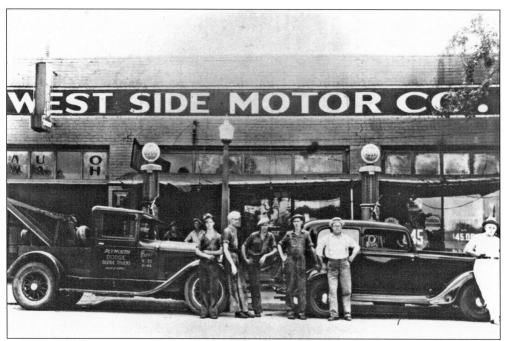

Shown here is West Side Motor Plymouth-Dodge located on Cedar Street. Pictured from left to right are (center foreground) Estell Bryant, David Dow, Ray Vickers, mechanic Charles Bryant, and salesperson Henry Dyer; (background) Finus Bryant and Charles Lee Bryant. J. L. O'Dell owned the 1933 Plymouth.

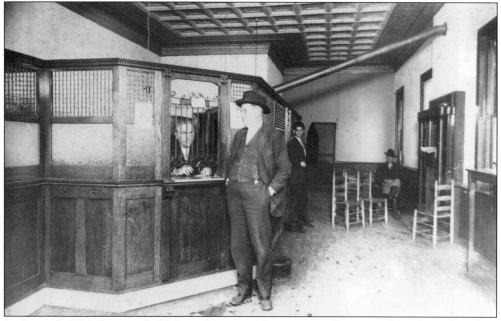

In this early 1914 photograph, H. Perry Morgan is discussing the business of the day with cashier S. B. Anderson inside the Cookeville Citizens Bank. John Anderson is standing in the rear of the building. The bank opened in 1911 in a new building across from the depot on the corner of Cedar and West Broad Streets. Hugh Hargis was president and S. B. Anderson was cashier.

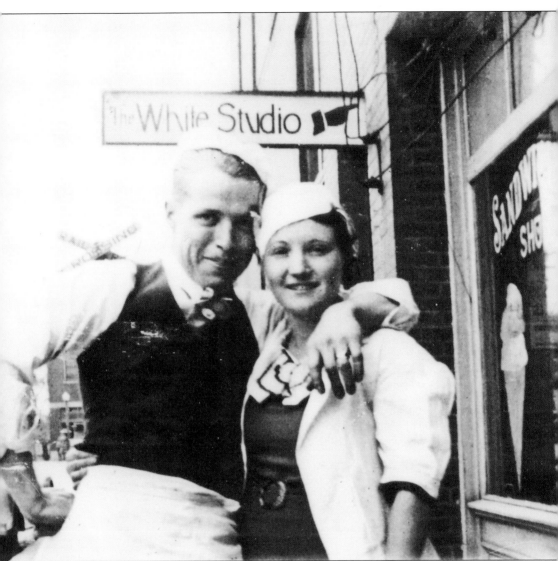

Located north of the intersection of Broad and Cedar Streets is the Sandwich Shop, owned and operated by Robert "Bobby" and Ruby Bussell Kendall in the 1930s. Customers could buy an ice cream cone for 5¢ and a sandwich for 10¢. Notice the White Studio sign at the top of the page, the Cookeville Citizens Bank on the corner in the background on the right, and the Shanks Hotel in the distant background on the left. (Courtesy of Burnece Bussell Franklin.)

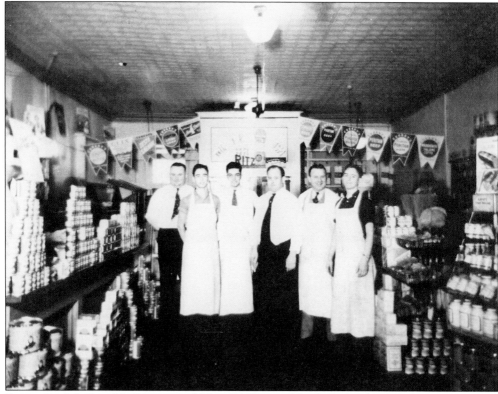

Pictured is J. J. Foutch's Grocery and Meat Market on North Cedar Avenue. Jesse James "J. J." Foutch is standing in the center with unidentified employees. J. J.'s father, Thomas "T. J." Jefferson Foutch, started the business in 1910. The Foutchs were in the grocery and meat business for almost a century.

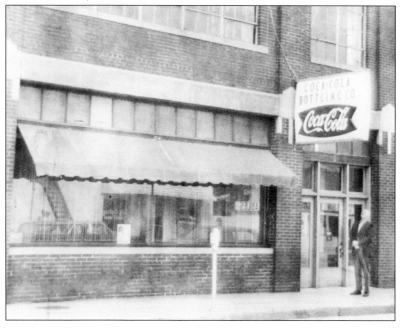

James Carlen stands in front of the Coca-Cola Bottling Company, which was first located on Cedar Street and, in later years, moved to their new building on West Spring Street. Coca-Cola has been in business in Cookeville since the early 1930s.

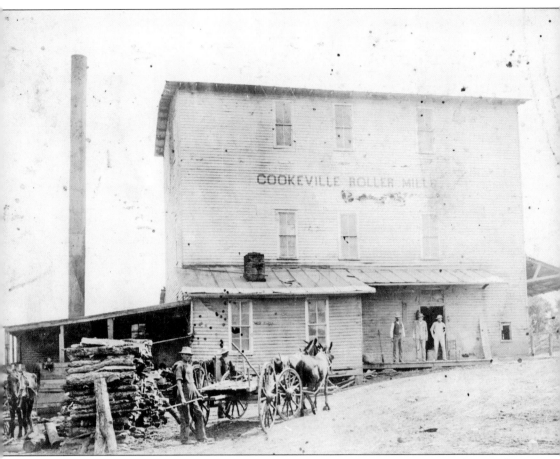

The Cookeville Roller Mill, owned and operated by James Barnes and Pleas Farley (pictured), was used for making wheat flour and corn meal. The wood-fired, steam-powered roller mill was located on Mill Street across from Cookeville Planing Mills. It was destroyed by fire in 1928. The photograph was taken in 1920.

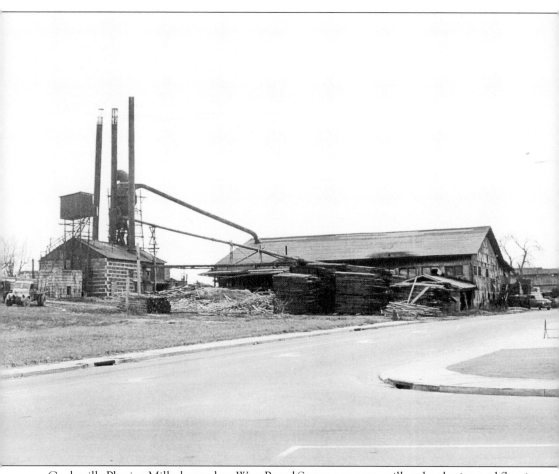

Cookeville Planing Mills, located on West Broad Street, was a sawmill and a planing and flooring plant. Robert W. Lowe Sr. started the business about the time the railroad reached Cookeville in 1890. What was to become known as the Cookeville Planing Mills was acquired in 1912 and prospered under Lowe's ownership until its sale to John H. Whitson, Walter L. Whitson, and Morrison L. Lowe Sr. in 1922. The operation grew to include several sawmills, a planing mill, and a flooring plant employing some 200 people by the 1950s. The manufacturing plant was scaled back to a retail yard in the late 1960s. It was sold to Robert Lowe Jr. in 1969 and operated as such until its closure in 1990.

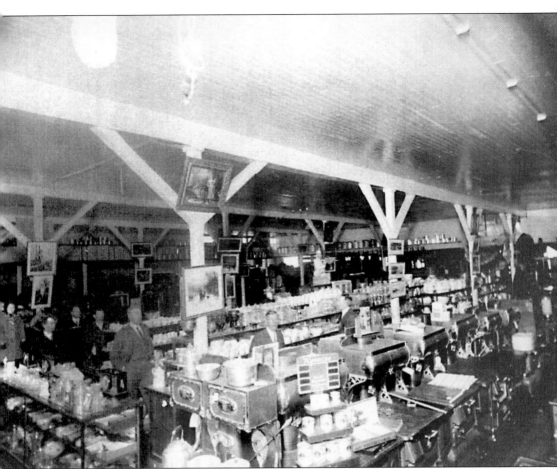

This picture of the interior of the Jere Whitson Hardware store was taken in the early 1900s. Jere Whitson established his business in Cookeville in the late 1800s on the northwest corner of the Public Square after moving it from Jeremiah in Overton County with his partner Alex Barnes. At that time, it was known as Whitson and Barnes Hardware and included a saddlery and buggy operation. This location was also the genesis of the Whitson Funeral Home. When the railroad came to Cookeville, Whitson opened a second location with new partners, Oakley and Dillard Massa, in what became known as the "west side" of town. This was on the northeast corner of Broad Street and Cedar Avenue along the railroad and enabled him to sell both wholesale and retail goods. The business stayed open until the late 1960s, selling not only hardware but housewares, furniture, appliances, paint, plumbing, and electrical supplies as well as building materials and farm supplies. The building now houses an antique mall and art gallery. In the foreground of this image are, from left to right, John H. Whitson (hands in pockets), Dillard Massa (center), and Walter L. Whitson. (Courtesy of Robert Lowe Jr.)

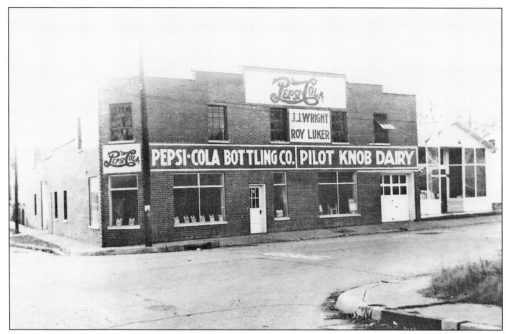

Jesse Owen founded the Pepsi Bottling Company in 1937. Pilot Knob Dairy was located next door at the corner of West Spring Street and Walnut Avenue. The building still stands but is used for storage.

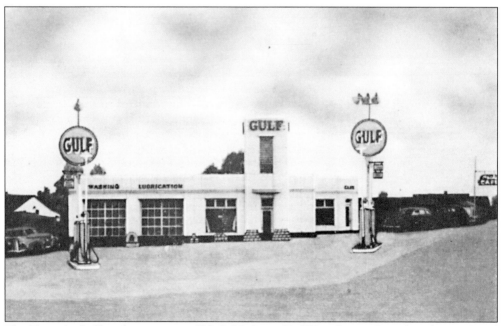

The Triangle Gulf at the junction of U. S. Highway 70 (West Spring Street) and West Broad Street was a popular spot for long-haul truckers to stop overnight. This ended in the 1960s when Interstate 40 took nearly all the traffic off this highway. It was called Triangle Gulf because the junction of West Spring Street and the beginning of West Broad Street formed a triangle.

Two

PEOPLE

Ann Trigg Robinson, born in 1874, was a graduate of the University of the South at Sewanee, Tennessee. She was first a teacher and then a nurse serving in a New Orleans hospital. Upon returning to Cookeville, her interest in history prompted her to keep meticulous written records of the heritage of the area. These records have proven invaluable to local researchers. (Courtesy of Laura Medley.)

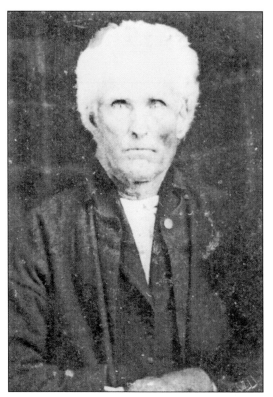

John Adams Barnes (1801–1874) received a 1,275-acre land grant from Tennessee governor William Carroll in 1826. He was married to Margaret Welch and was the son of Thomas Barnes, an early pioneer settler of Putnam County.

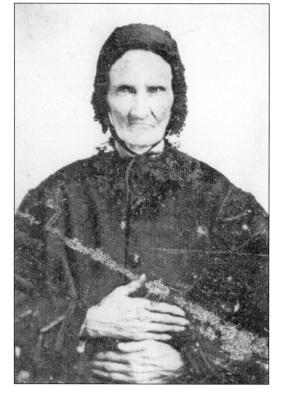

Margaret Welch Barnes, wife of John Adams Barnes, had eight children: seven daughters and one son. Margaret was born in October 1790 and died in July 1879. The children of Margaret and John were Mary, Alice, William H., Anna, Lucinda, Rebecca, Martha Jane, and Sarah "Sally" L. Barnes. Jeremiah and John H. Whitson married sisters Lucinda and Sally.

Stephen Hayden Young was born at White Plains in October 1874. After graduating from the University of Tennessee, he married Effie Boyd. Mr. Young helped organize the Gainesboro Telephone Company, which relocated to Cookeville in 1908.

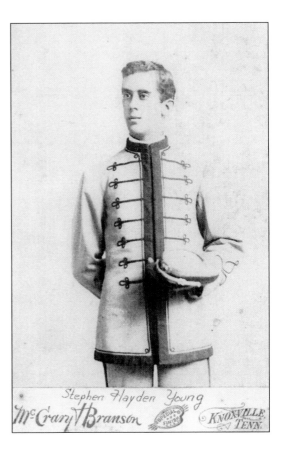

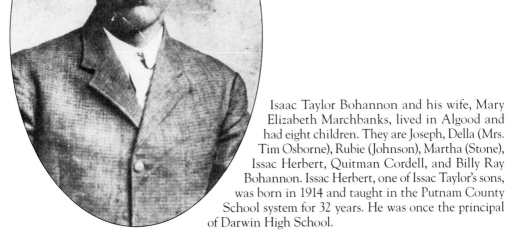

Isaac Taylor Bohannon and his wife, Mary Elizabeth Marchbanks, lived in Algood and had eight children. They are Joseph, Della (Mrs. Tim Osborne), Rubie (Johnson), Martha (Stone), Issac Herbert, Quitman Cordell, and Billy Ray Bohannon. Issac Herbert, one of Issac Taylor's sons, was born in 1914 and taught in the Putnam County School system for 32 years. He was once the principal of Darwin High School.

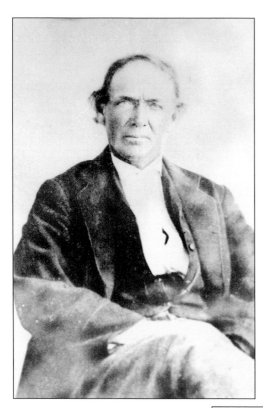

Stephen Decatur Burton (1812–1892) married Mary "Polly" Coe Davis Goodbar (1819–1895), and they had six children: Benjamin Franklin, Francis, Mary Caroline, Catherine Annette, Charles, and Emily. Stephen was the son of William Pennington Quarles and Ann Hawes Quarles, who came to White Plains in 1809.

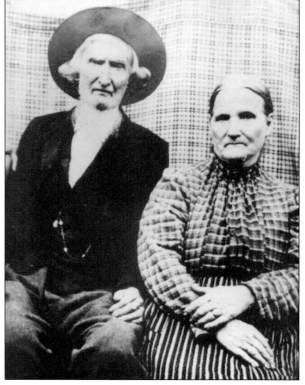

This photograph was taken in the late 1890s of William C. T. Bussell and Charlotta Nash. William was born in the Burgess Falls area of Putnam County in 1818. He was the son of John Edgar Bussell Jr., who lived in the area in 1810. William was married to Liza Jane DeWeese and had four children with her. After Liza's death in 1843, William married Charlotta. They had six children. William died in 1818 at the age of 89 and is buried in the West Cemetery.

Here are Frank Lee Finley and Myrtle Ann (Deck) Finley on their wedding day in January 1924.

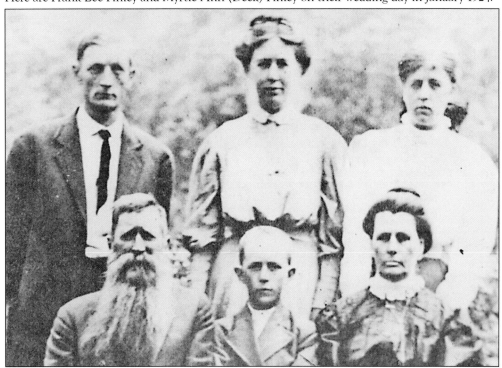

Pictured here are Stephen Decatur Quarles (1843–1920) and his family. Pictured from left to right are (first row) Stephen Decatur Quarles, Stephan Brice, and Mr. Quarles's second wife, Mary Ann King; (second row) James Lafayette, Lou Ella, and Ida. Stephen Decatur Quarles first married Zahilla M. Jones, and they had four children: Daniel Hawes, Birdie, Mollie, and Emily.

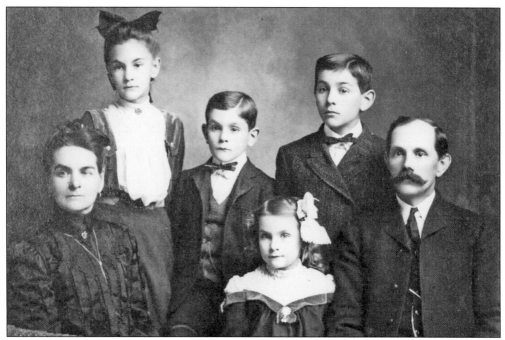

Pictured here is the Alexander P. Barnes family. From left to right they are Fannie Terry Barnes, Ethel Barnes Darwin, Zeb Barnes, Matalee Barnes Mitchell, Jere B. Barnes, and Alex P. Barnes. Alex was a successful merchant in Cookeville and was mayor in 1923. Zeb Barnes operated a shoe store on West Broad Street. Ethel married Charles Darwin, a partner in the Jenkins and Darwin's dry goods store, and Matalee married John A. Mitchell, who was district attorney general and later judge on the court of appeals in Tennessee.

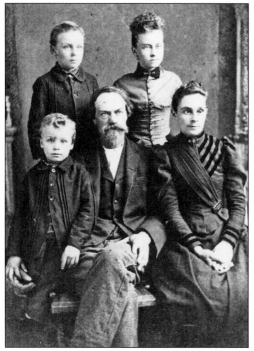

David Dow Huddleston was the son of John Lewis Hobbs Huddleston and the grandson of David Huddleston. They came here from Rutherford County, North Carolina, in 1811, and they settled in the Salem community of Putnam County. David Dow Huddleston married Eunice Bennett. They are shown with three of their children. Pictured from left to right are (first row) Lewis Dibrell, David Dow Huddleston, and Eunice Huddleston; (second row) Green Lee Huddleston and Minnie Huddleston. Not pictured is Sally Ever Dimple, who was born after the picture was taken. The Huddlestons are buried in the Salem Cemetery in Putnam County.

Shown here are George Dibrell Boyd and his wife, Belle Nicholas Boyd. Mr. Boyd was a prominent farmer in the county who lived on Boyd-Farris Road near Cookeville. The Boyds had several children: Henry, Aubry, John H., Minnie, Asbeny, Dibrell, and Hartford. The family was active in farming, dairying, and county affairs. Jane Boyd, widow of Dibrell Boyd, still lives on the family farm, which has been occupied by the Boyds since 1852.

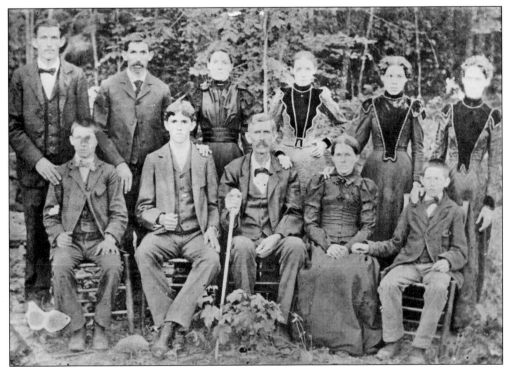

William Wade Woodfolk Maxwell was the son of Amos D. Maxwell (1803–1863) and Mary Patton Maxwell (1798–1875 or 1876). He married Sarah Francis Gentry (1846–1904), and they had nine children. Seated in center front are William Wade Woodfolk Maxwell and Sarah Francis Gentry Maxwell. The children's names in no particular order are Mary Loucinda, Durra, John Matthew, Idema Nancy, George Morgan, Linton, Clarence, William Dero "Dee," and Vander Vernon.

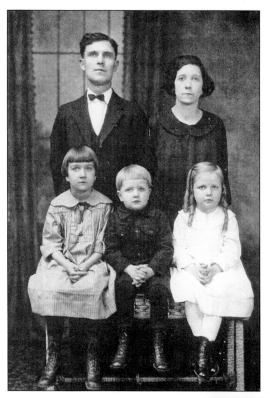

Charlie B. Ensor and his wife, Pearl Huddleston Ensor, are shown here with their children. From left to right they are Maurine Ensor, who married Robert Patton; Charles Ensor, who married Reba Young; and Eleanor Ensor, who married Clarence T. Huddleston. Charlie B. Ensor's parents were William Wirt and Monsie Amonett Ensor. Pearl Huddleston Ensor was the daughter of Bettie Huddleston.

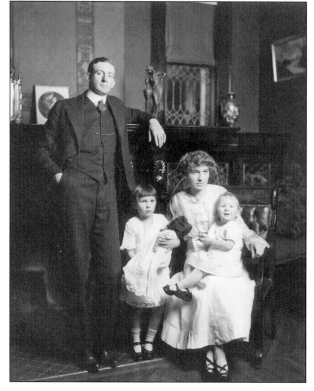

Harvey Thurman Whitson, known as H. T., and his wife, Beulah, are pictured here with their children, Mary Francis and Jere Boulegard. H. T. Whitson had lumber interests in Tennessee and Kentucky. He was postmaster in Cookeville for a time and also was a force in the Democratic Party locally, statewide, and nationally.

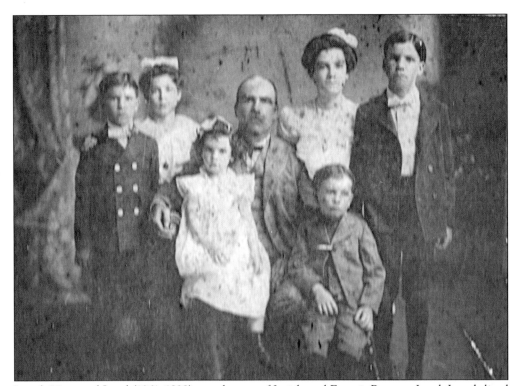

Joseph Haywood Jared (1861–1898) was the son of Josiah and Francis Bennett Jared. Joseph lived with his family in the Rock Springs area of Putnam County. When school was in session, he rented a house in Cookeville and brought his children to town for the school term. Mrs. Jared died in 1898, leaving Mr. Jared with their six children to raise. Shown here from left to right are Robert Ralph, Mary Bryan Jared Miles, Flossie Neil Jared Lowe, Joseph, Hallie Hancock Jared Travis, Walter Bennett, and Horace. Later Joseph Jared married Ina McCaleb, and they had three children: Morgan, Houston, and Joyce. (Courtesy of Laura Medley.)

Pictured here are the family members of John Terry and Francis America Dowell Terry. From left to right they are (seated) Jere Whitson, Parizetta Francis Terry Whitson, Mattie Kirkpatrick Terry, and Lee R Terry; (standing) John Dowell Terry, Whitley Charles Terry, and Joel Wesley Harvey Terry. John Terry's father, James Terry, came to this area in 1815.

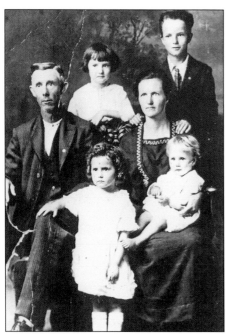

Arthur Bussell and his wife, Ritha Davis Bussell, are shown here with their children. They are, from left to right, (front) Burnece (Franklin) and Hubert Wiley; (back) Ruby (Franklin-Kendall) and Paul Davis Bussell. Fred Bussell is not pictured. Arthur was the son of Meredith Daniel Bussell and Nancy Fraley Bussell. Ritha was the daughter of John R. Davis and Sarah Eldridge Davis. Before he moved his family to Cookeville in the 1920s, Arthur was a prosperous farmer from the area known as Fanchers Mills.

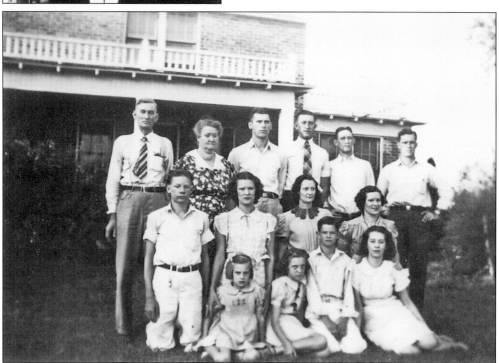

Pictured here are members of the Joseph "Joe" Cronk family gathered on the steps of their home in the late 1930s. The house was located across the road from where the Plateau Mental Health Center is today. Mr. Cronk and his wife, Effie Lou Prentice, are with their 12 children whose names, in no particularly order, are Archie Ray (who is 100 years old to date), Norma, Alma, Audrey May, Ola, Grady, Joseph Jr., Howard, Evelyn, Helen, Haywood, and Benton. (Courtesy of Joyce Cronk Joseph.)

Pictured are Mrs. Minnie Brown Shipley, James Avery Welch, and Luther Crabtree on the mule. Mr. Welch was the grandfather of Dr. Thurman Shipley. The store sold groceries and other general merchandise. It was located 2 miles north on the Old Pike, which is now the corner of Broad and West Jackson Streets.

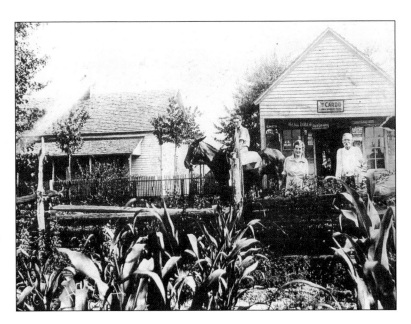

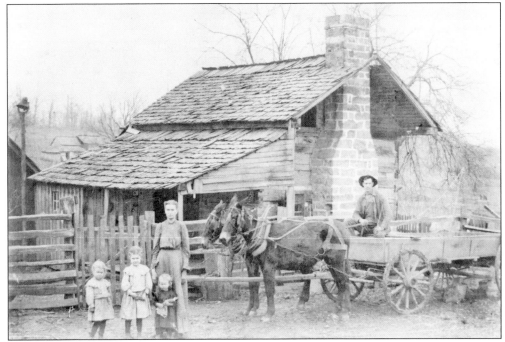

The John A. Boatman family lived in northern Putnam County off Mirandy Road. Pictured in front of their home, John A. Boatman is sitting in the wagon, and his wife, Irene Cobble Boatman, is standing. In front, from left to right, are the couple's three children, Myrtle Boatman Breeding, Nellie Boatman, and Gertha M. Boatman. John was the son of Rice and Francis Ann Warren Boatman. Irene's parents were Joseph M. Cobble and Tennessee L. Bilbrey Boatman.

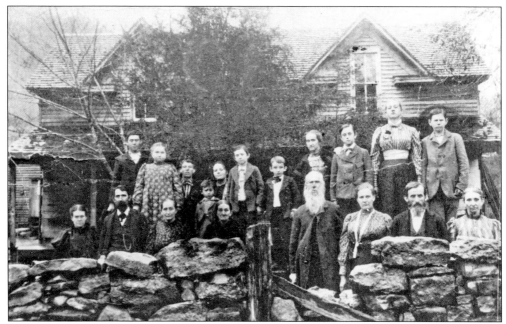

Pictured around the old rock wall is the Brindley family. From left to right they are (first row) Tennie Beatrice Brindley, Campbell Brindley, Anne Petty, Mary (McKinley) Brindley, Benjamin Franklin Brindley, Bobby Petty, Taylor Burton, and Elzia Burton; (second row) Benjamin Brindley, A. V. Petty, Bob McKinley, Henry Brindley, Donna Brindley, Jim Brindley, Grady Burton, Sally Petty Brindley, unidentified, Genny Petty, and Oather Cannon.

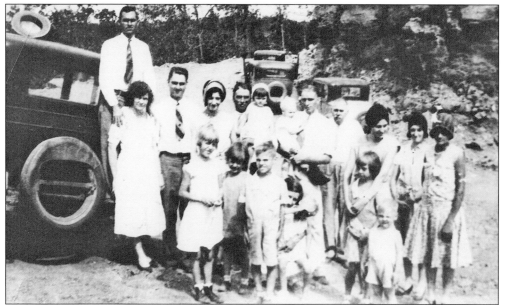

At a family gathering near a local lake are members of the Hodges family. Standing on the running board of the car is Arlice Hodges. His wife, Willie Mae Bowden Hodges, is immediately in front of him (his hands resting on her shoulders). In the front row, beginning third from the left, are Houston Hodges, Virginia Hester Hodges, and Earl Glenn Hodges. The remainder of the people in the photograph are unidentified.

54

Pictured here from left to right are Carlen brothers Benton, Herman, Herbert, Algood, and Walter. The photograph was taken in the home of Robert Lowe Sr. on North Washington Avenue.

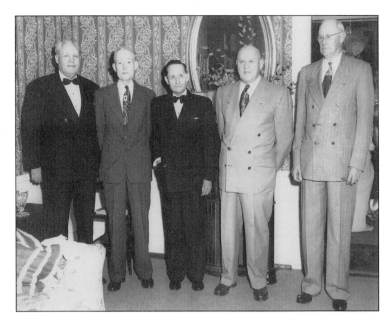

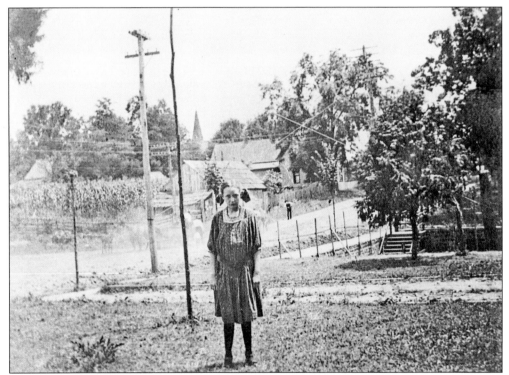

This photograph was taken of Francis Lucinda "Fanalou" Whitson as a young girl in the front yard of her home, the Jere Whitson residence on North Dixie Avenue. Fanalou later married William Benton Carlen. Also visible toward the southeast are the steeple of the Cumberland Presbyterian Church, a cornfield, a barn, and men leading livestock down the dirt road that is now Dixie Avenue. The steps in the background lead to the town spring.

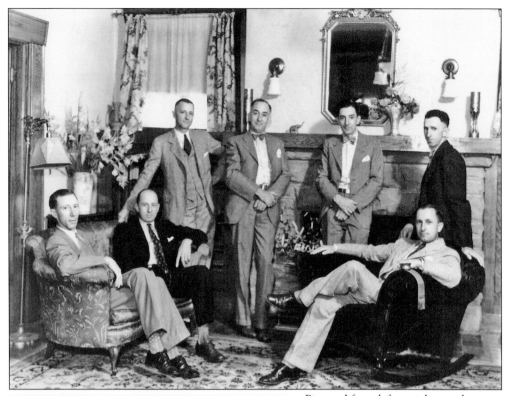

Pictured from left to right are the following Darwin brothers in the home of Claude Darwin: (seated) Dero, Ottis "Ott," and Dick; (standing) Claude, Charles "Charlie," Lee, and Hugh. The home is located on North Dixie Avenue.

This photograph of Dero Darwin was taken in 1916 at Pleasant Hill Academy where he was a student. Dero was one of seven brothers who lived in Jackson County. After moving to Cookeville, Claude, Charles, and Dero Darwin collaborated with Sid Jenkins as owners and operators of Jenkins and Darwin Dry Goods.

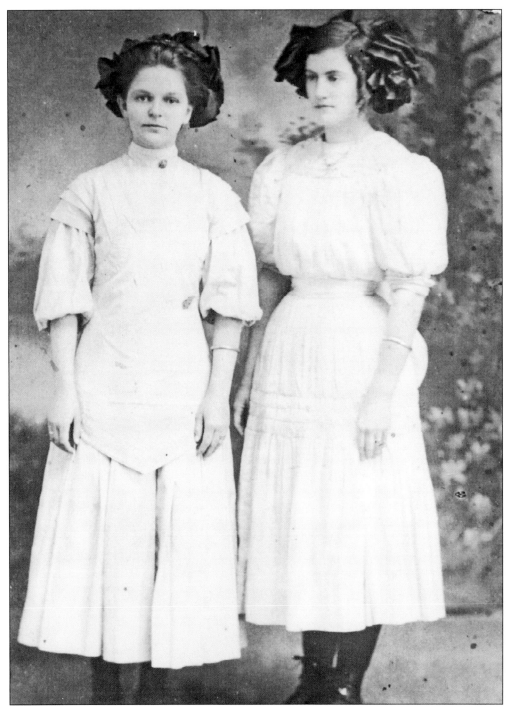

Linnie Buck (left) and Lizzie Buck were daughters of Isaac Newton Buck. Their home is still standing on Buck Mountain Road at the corner of Dry Valley Road. Isaac Newton Buck brought his family to the area in 1820. He purchased land for a college in 1849 and built Andrew College, more familiarly known as Buck College. It was the first-known secondary school in the county. It closed during the Civil War and never reopened.

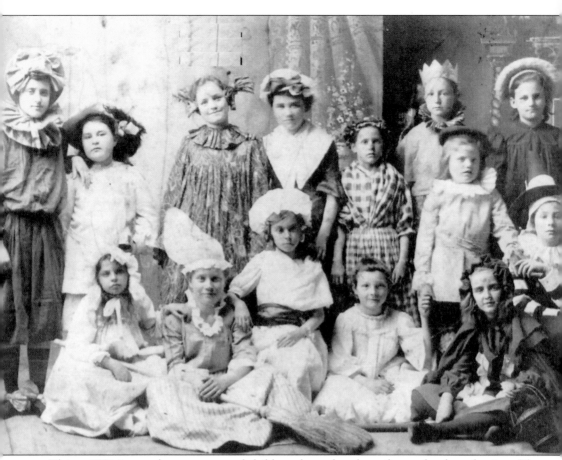

This *c.* 1901 image shows a group of children dressed perhaps for a school production. Ten-year-old Artie Mae Barnes, third from the left in the back row, is the only one identified in the photograph. Artie was the youngest daughter of Dorcus Montgomery and Jesse Crockett Barnes. She attended Buford College in Nashville and married Dr. Frank Williams of Temperance Hall, who practiced pharmacy in Lebanon. She taught music and art in Cookeville, Buffalo Valley, and Temperance Hall. Her children were Dorothy Elizabeth (Fredeking), Frank Williams Jr., and Jesse C. Williams. Artie Mae died at age 47.

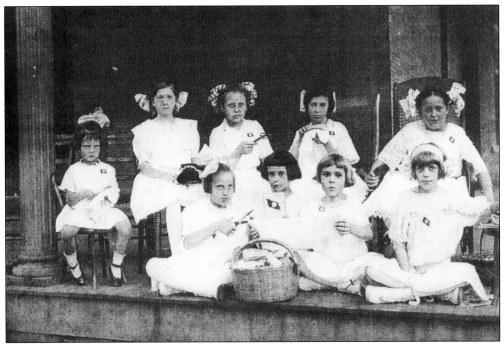

A group of young women attends a sewing class. Dollie (Smith) Williams is third from left in the front row. Private sewing classes were offered to the young women in the area.

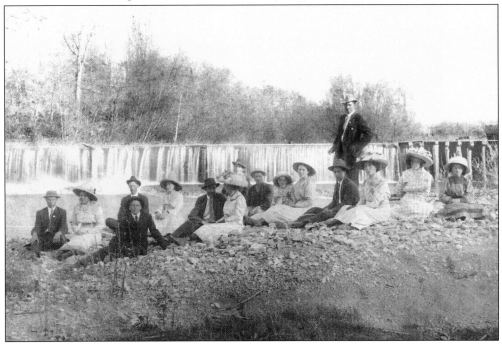

Shown here is the wedding party of Grover Cleveland Whitson (1890–?) and Alice Hawkins (1890–1923) at the dam at Cummins Mill in 1912. They are third and fourth from the left. Their children, U. L. (1913–) and Lillian (1916–2001), were born in a log cabin on a corner of their grandfather Bill Whitson's farm.

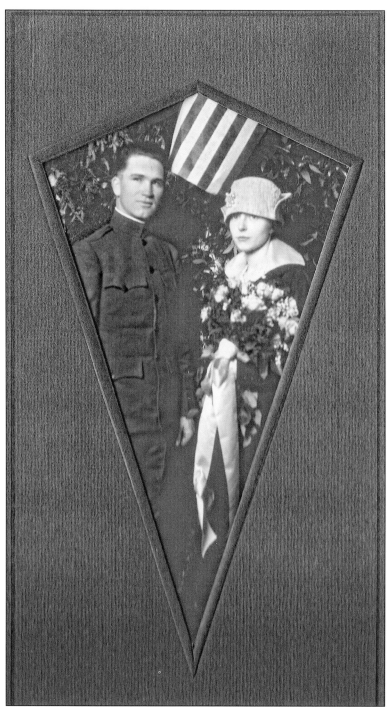

The wedding of Robert Ralph Jared and Mary Cummins Lowe occurred while he was on leave during World War I in January 1918. Later he saw action in the trenches of France, where he was killed as a young man. He was the son of Joseph Haywood Jared and Laura Neil Shields Jared, who was the daughter of Gideon Harris Lowe Sr. and Lucy Virginia Cummins Lowe. Mary is the mother of Lucy Jared Stanton and Mary Ralph Jared Maddux.

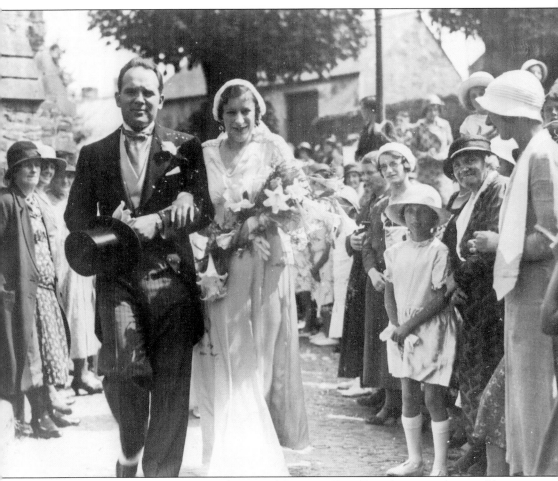

Pictured are Dr. William Everett Derryberry and Joan Pitt-Rew Derryberry on their wedding day in England. Mrs. Derryberry was an accomplished musician, who organized and supported many cultural events and musical programs area-wide. "Mrs. D.," as she was affectionately called, composed and played a sonata in the first major concert of the Tennessee Tech Music Department in 1948 and was the composer of the Tennessee Tech hymn. During Dr. Derryberry's tenure as president of Tennessee Polytechnic Institute, now Tennessee Technological University, enrollment increased, it became a university, and state funding was secured to operate the Seventh Street School as a training ground for teachers. Later the school's name was changed to Tech Training School. Under Dr. Derryberry's guidance, the school offered master's degrees in engineering and education. New dorms and classrooms were built to accommodate the increased enrollment.

Clara Cox Epperson (1869–1937) was the inspiration behind the establishment of two libraries in Putnam County. She was born in Gainesboro, Tennessee, and attended school there. Later she attended Price's Nashville College for Young Ladies. Clara taught for a few years before her marriage to John Epperson. The two moved to Algood, where she started a small library with her books. After her husband's death in 1919, Mrs. Epperson moved to Cookeville to live with her daughter, Mrs. W. A. (Elise) Howard, at which time she became involved with the community. Clara was an organizer of the Book Lovers Club (one of the oldest Cookeville Clubs still in existence) in 1921, and she rallied the group to create the first library for the city. She was an author, publishing many articles, poems, and children's stories locally and was a strong advocate for women and education. Mrs. Epperson served once as poet laureate of Tennessee. After her death, the Cookeville Library was named the Clara Cox Epperson Library.

Ernest Houston Boyd was born in 1880, graduated from Cumberland University, and soon after married Mattie Ragland. Mr. Boyd held offices of county superintendent and county attorney as well as attorney of the fifth judicial court circuit. He practiced law with his brother Grover C. Boyd. (Courtesy of Julia Boyd.)

Grover C. Boyd was born in 1891 and attended Cumberland University but graduated from Georgetown University. In 1916, he served in World War I and came back to practice law with B. G. Adcock for a few years before leaving to practice with his brother Ernest in Cookeville.

Luke Medley moved to Cookeville from Buffalo Valley to attend Tennessee Polytechnic Institute in the 1920s. He owned and operated the first radio station in Cookeville, WHUB, one of only 14 stations operating in the state. In 1944, WHUB became affiliated with CBS. Medley sold to Paxton in 1998. He was county judge for two terms and served as mayor for two terms. Medley was very active in promoting business in Cookeville. (Courtesy of Martin Medley.)

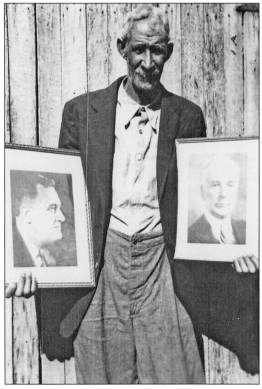

Robinson Crusoe Buck was a highly respected person who lived in Algood, Tennessee. Buck was born in 1846 and died in 1956 at the age of 110. During the Civil War, Buck hid and cared for his master while the Union soldiers were in the area. He became a free man and acquired 400 acres of land now located in Algood. He was most generous, donating land for a school and church. While driving Cordell Hull (then circuit judge in Putnam County) around the area in his horse-and-buggy, Buck and Judge Hull became friends. Buck, by invitation, went to the White House to meet Pres. Franklin Roosevelt, possibly at the urging of Cordell Hull.

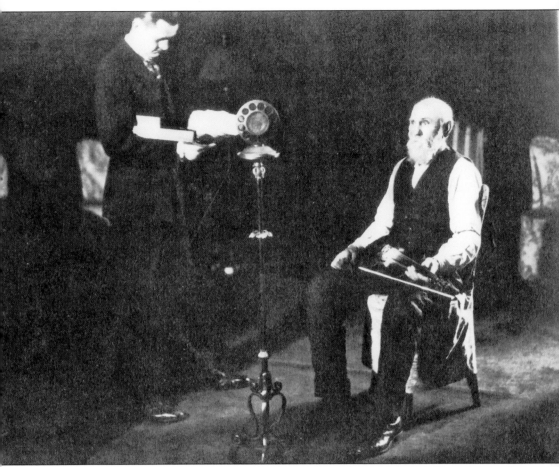

Jessie Donald Thompson ("Ole Uncle Jimmy," 1848–1931) was born in Baxter, Tennessee, and had two brothers. The Thompson family moved to Texas when Jimmy was young. He moved back to Tennessee near Smith County where he met and married Mahalia Elizabeth Montgomery. They had two sons and two daughters: Jess, Willie Lee, Fanny, and Sally, who died at birth. Uncle Jimmy learned to play the fiddle in Texas as a child. He packed up his family and moved back to Texas to farm in Bonham where he won his first fiddle contest. After fiddling and farming, he moved his family back to Tennessee to Hendersonville where Mahalia died of cancer. He fiddled around Tennessee as a regional fiddler and, at the age of 77, began broadcasting on WSM Barn Dance as the Tennessee Waggoner. The Barn Dance became the world-famous Grand Ole Opry. He died of pneumonia two years after making his radio debut.

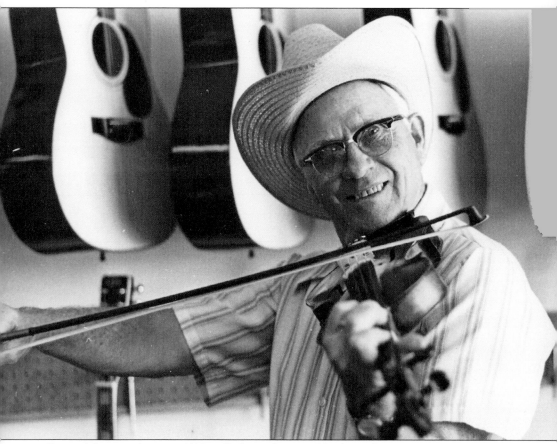

Frazier Moss was born in 1910 in Jackson County. He showed a great interest in music at an early age, and at eight he had his own fiddle. He became one of the premier, authentic, old-time Southern fiddlers. He won nearly 100 fiddling contests, including the North America Old-Time Championship in Omaha, Nebraska, in 1977. Frazier won six consecutive Southeast U.S. Tennessee Valley championships in Athens, Alabama. Frazier died in 1998 at the age of 88.

Three

CULTURAL AND SOCIAL

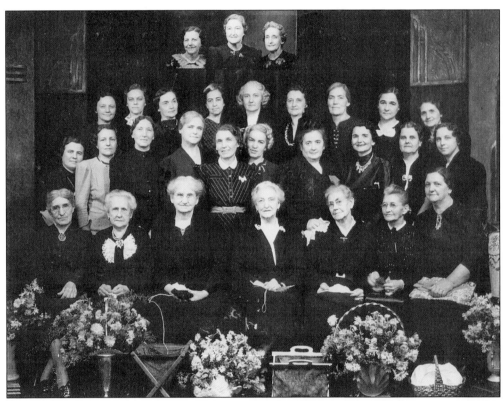

The Cookeville Sewing and Garden Club was a social club that was active for many years. In this early photograph from left to right are (first row) Mrs. Narcissus Wilhite, Mrs. Minerva Carlen, Mrs. Althea Vaden, Mrs. Parizetta Whitson, Mrs. Tom Ford, Mrs. Lucy Lowe, and Mrs. Sam Pendergrass; (second row) Mrs. Bunola Marchbanks, Mrs. Sara Wilhite, Mrs. Lorelle Maddux, Mrs. Dillard Massa, Mrs. Thurman Whitson, Mrs. Flossie Lowe, Mrs. Effie Young, Mrs. Elizabeth Shanks, Mrs. Myrtle Whitson, and Mrs. Mamie Carlen; (third row) Mrs. Mattie Massa, Mrs. Elizabeth Rice, Mrs. Gilbert Draper, Miss Alice Keith Ford, Mrs. Fanalou Carlen, Mrs. A. G. Maxwell, Mrs. Jesse Drake, Mrs. Jim Anderson, and Mrs. Elizabeth Carlen; (fourth row) Mrs. Douglas, Mrs. Mary Alice Lowe, and Mrs. Lockie Haile. (Courtesy of Mrs. Sharon Defosche.)

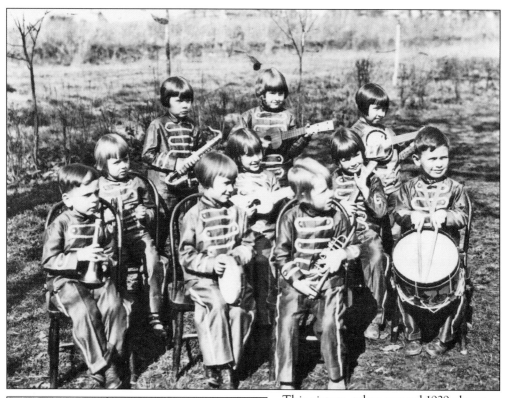

This picture, taken around 1929, shows students in a children's band directed by Etta Johnson Dyer. Dyer had the only kindergarten class in Cookeville, which also included first, second, and third grades. From left to right are the following students: (first row) Morrison Lowe Jr., Mildred Ware, and Willene Walker; (second row) Mildred Wilhite, Charlene Foster, Catherine Walker, and Harvey Ragland; (third row) Alahanna Sparks, Cynthia Lowe, and Betty Reeves.

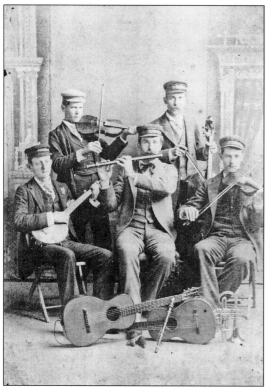

Cookeville's first known orchestra was organized in 1886 or 1887. Rutledge Smith (center), playing the flute, and Benjamin Franklin Sloan (back row, right) are the only people identified in this picture. Smith was involved in many different aspects of life in Cookeville and took a prominent role in promoting a higher quality of life in the community.

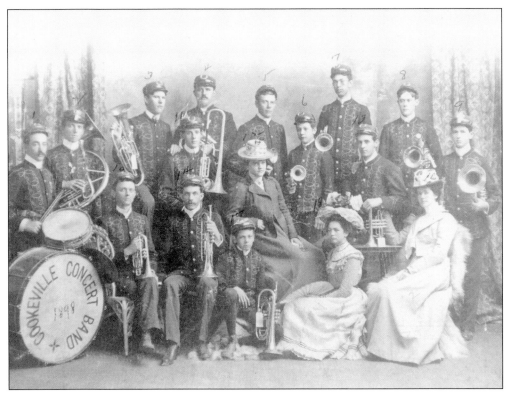

In 1898, Putnam County residents enjoyed music and theater. Concerts and parades were well attended and in great demand. With the interest in music, bands were organized throughout the area. This early orchestra began in 1904 and was called the Cookeville Concert Band. It was made up of local musicians and was the forerunner to the Tennessee Polytechnic Institute 17-piece orchestra. Cookevillians subscribed to a lyceum series with visiting guest artists.

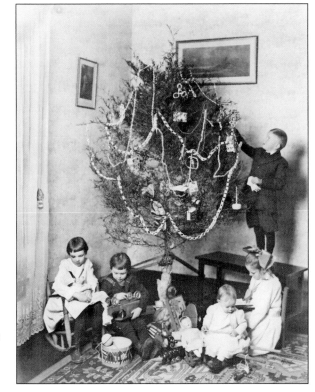

Christmas Day in the 1930s at the Whitson home on Washington Avenue was a happy celebration. Mary Francis is on the left, and Jere Whitson is on the right. The other children are unidentified. Notice the popcorn string on the tree.

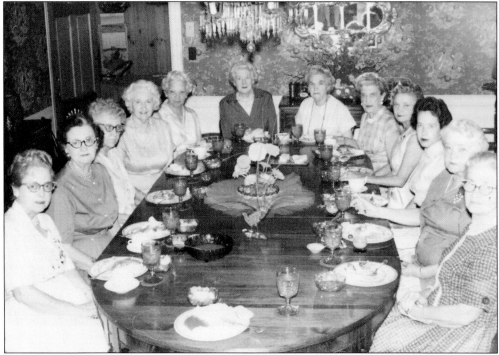

The Round Dozen Club started in the 1930s. This group of women met on a regular basis for several years to visit, eat lunch, and play bridge. From left to right are Mary Alice Lowe, Flossie Lowe, Fanalou Carlen, Helen Overall, Vena Mae Maxwell, Elise Howard, Beulah Whitson, Ethel Carlen, Mildred Moore, Mary Alexander, Clio Darwin, and Elizabeth Carlen. (Courtesy of Melinda Bilbrey Swann.)

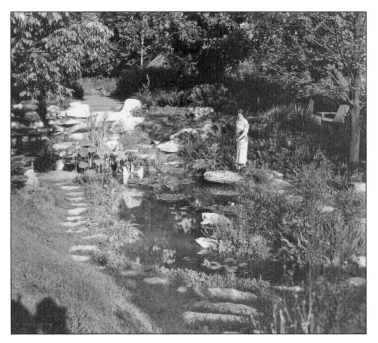

The Claude Darwin garden is pictured here around 1940 with Mrs. Claude Darwin in the background. There was a rock wall with water trailing down and meandering through the carefully planned rocks into two different pools of water. In summer, Mrs. Darwin removed the water lilies and replaced the pond water with clean water so her grandchildren could swim. The Darwin home was located on North Dixie Avenue.

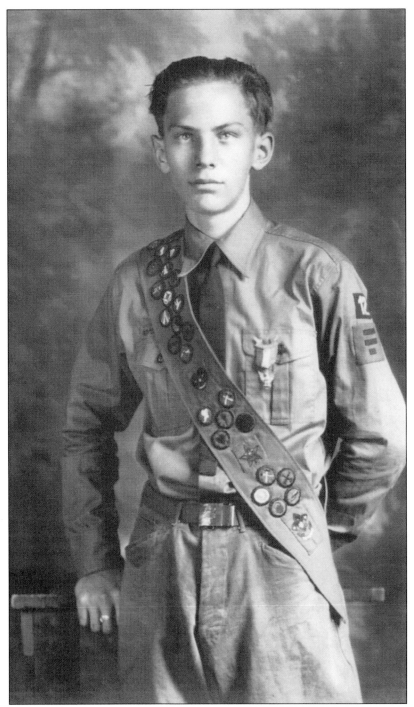

Pictured is Alard Clark Harding (1915–1980). He became the first Eagle Scout of Putnam County on December 28, 1928. He had earned 28 merit badges at that point. Troop No. 12 was chartered in 1912 and later became Troop No. 108 as the districts were reorganized in 1930. Alard was the son of Mr. and Mrs. Richard Henry Harding, who founded Harding Studio in 1913 and who took this photograph as well as numerous others in this publication. (Courtesy of Dr. Steve Johns.)

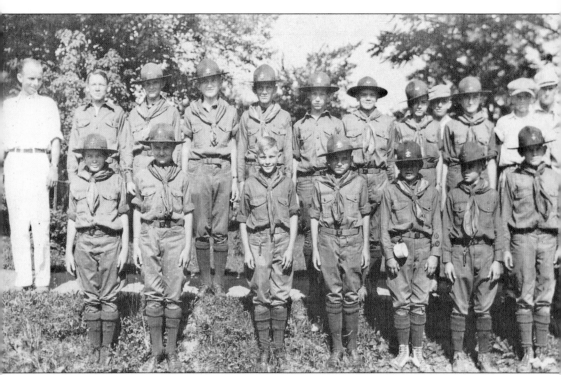

Cookeville Scout Troop No. 12 of 1928, dressed in their uniforms, leggings, kerchiefs, and hats, is standing at attention for photographer R. H. Harding of the Harding Studio. In historical terms, No. 12 was the original troop chartered in 1912 by the Methodist church and scoutmaster Howard Wirt. Pictured from left to right are (first row) William Oliver Terry, Joe Dyer, James Thompson, Douglas Carmack, Arnold Camaeron, Jimmy Cox, and Joe Adams; (second row) scoutmaster Charles Sharp, Jere B. Whitson, Hardin Boyd, Dave Maddux, Allard Clark Harding, Samford Shipley, Owen Edward "Buddy" Cameron, Kenneth Haile, Jack Hughes (in back), and Cecil Gentry (identity uncertain). Those not in uniforms at right are not identified. (Courtesy of Dr. Steve Johns.)

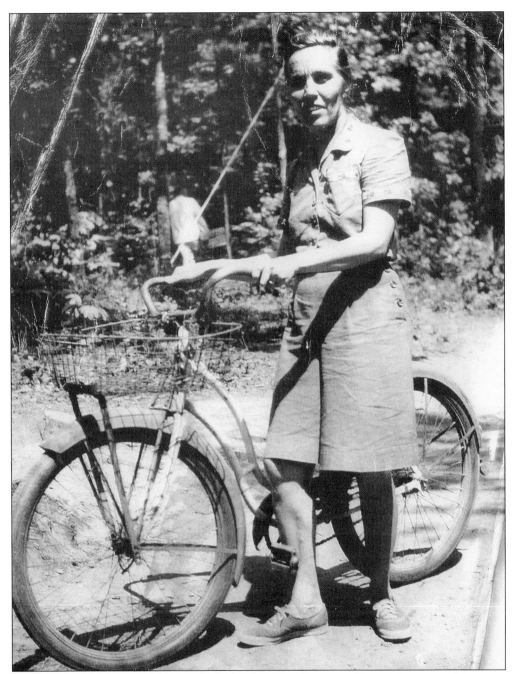

Dollie Smith Williams rides her bicycle at the girl's camp known as Camp Monterey in Monterey, Tennessee. Mr. Malcolm and Mrs. Williams found this large tract of land surrounding the Monterey Lake in 1945 during World War II. Built by German prisoners of war, the camp offered horseback riding, hiking, arts and crafts, tennis, archery, water sports, riflery, and nature study. There were 125 young women enrolled the first year, and the number increased continually, prompting the 1963 construction of a boy's camp close by called Country Lad. Both camps are still in operation and are very popular.

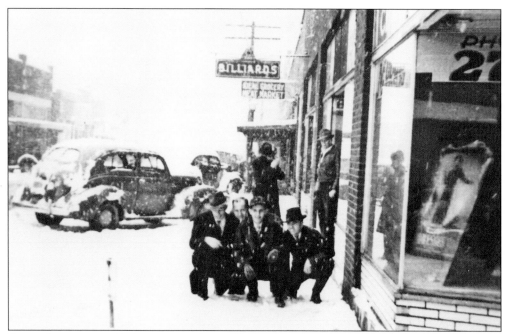

Pictured is a wintry 1940s scene on the west side of Cookeville. Billiards halls were a common sight on the streets of southern towns during the 1940s and 1950s. Shooting pool was a popular form of entertainment, and the local pool hall served as a gathering place for many in the area.

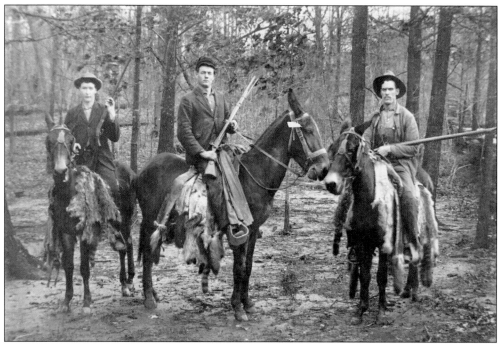

Three hunters return from the woods with their bounty. This photograph was taken around 1910 in the Bear Creek area of Putnam County. Pictured from left to right are Henry Moore, Orley Warren, and John Boatman.

Four

BUSINESSES

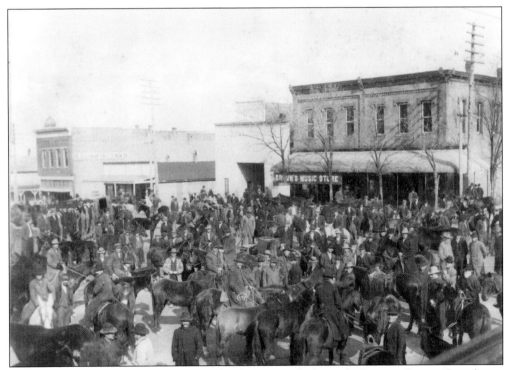

In this photograph looking east, buyers and seekers are packed into the Putnam County Courthouse Square on Mule Day in the early 1900s. Mule Day was very important to farmers in the area since the mule was a staple for most all work done on the farm. Most the mules in the area came from a Lebanon, Tennessee, firm that worked the animals on hillsides for a few years to make them sure-footed.

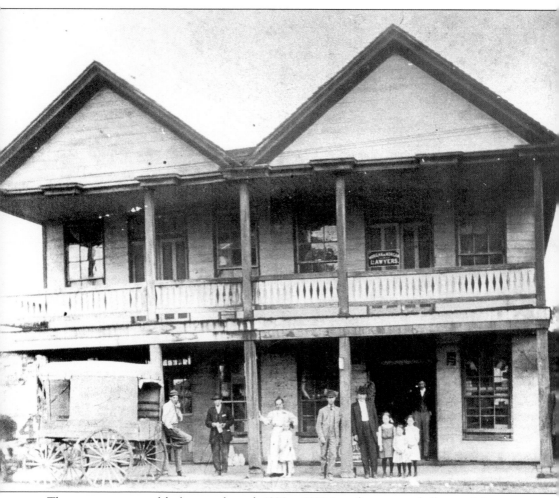

There was a great need for lawyers through 1890 to 1920. Law firms opened all around the country. Walter S. McClain, George H. Morgan, Harrison G. Morgan, Henry P. Davis, T. L. Denny, W. G. Currie, Robert B. Capshaw, Holland Denton, John S. Denton, J. W. Puckett, A. N. Ford, Grover C. Boyd, Oscar K. Holladay, H. S. Barnes, and Linnie M. Bulling were Cookeville lawyers. This is an early photograph of the law firm known first as Morgan and Morgan or Morgan Brothers Law Firm and later as Morgan and Davis Law Firm, located on the square in the 1890s. George and Harrison Morgan became associated with Henry P. Davis, who was the first person from Putnam County to represent both Putnam and White Counties in the legislature.

Marchbanks Drug Store was on the east side of the courthouse square. There was a soda fountain along with cream pies and sandwiches made by Margaret Hale, the wife of one of the pharmacists, Dr. Steve Hale. The other pharmacist was Dr. Howard Garrison. The drugstore burned sometime after 1961.

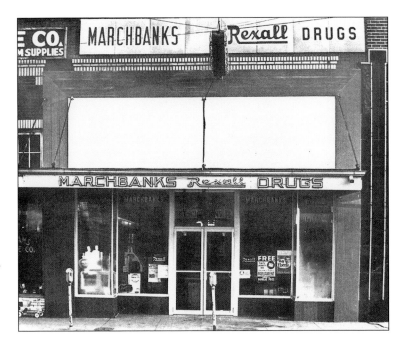

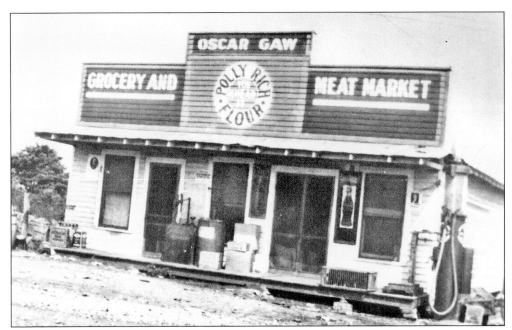

The Oscar Gaw store was located at the corner of North Dixie Avenue and Jere Whitson Street. They sold produce.

Murray Ball's first jewelry store was located on the courthouse square on the corner of Broad Street and North Jefferson Avenue. Ball operated his store on this site from the spring of 1926 until the fall of 1929, when he moved into this new building on West Broad Street. He stayed in business there until he retired in 1954. Murray Ball and his wife, Dolly McKinney, moved their family to Cookeville in 1926. This photograph shows Murray Ball on the left and his son Avery Ball on the right.

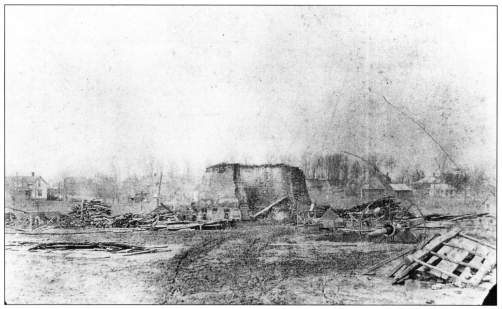

The Scott brick kiln was used to make brick and was located across from Cookeville City Cemetery on Scott Avenue. Joe Scott owned and operated the kiln in the 1920s and 1930s. Joe owned a large tract of land in that area.

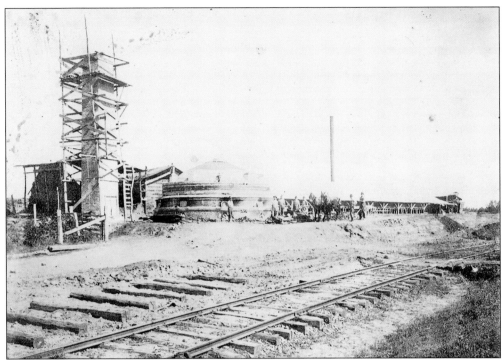

This is a very early photograph of the Algood Brick Kiln located on Mirandy Road.

This is a photograph of People's Stockyard located on South Jefferson Avenue. I. B. Brooks, Lloyd Nash, Phillip Martin, and James Robbins opened the stockyard in 1947. It is still used today for the same purpose.

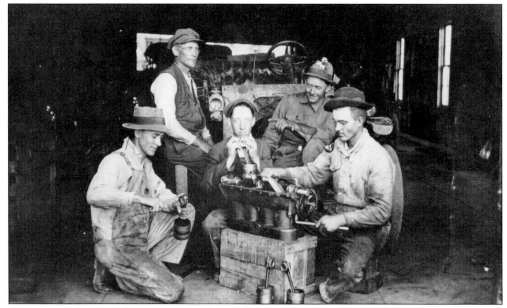

This group of men gathered in Algood to work on the motor of a Model T in the early 1900s. Pictured from left to right are Lawrence Simmons, Mars Simmons, Rufus Runt Wright, Brice Quarles, and Ham Williams, who was the brother-in-law of Gaskell Gragg.

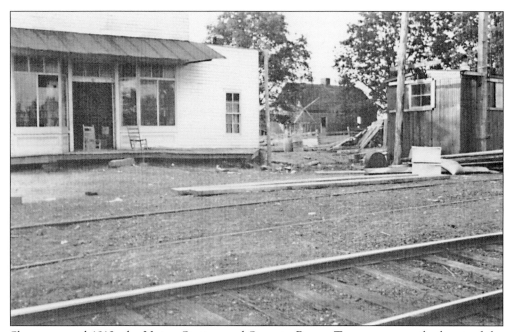

Shown around 1912, the Union Station and Store in Boma, Tennessee, was the heart of the district traversed by the Tennessee Central Railroad.

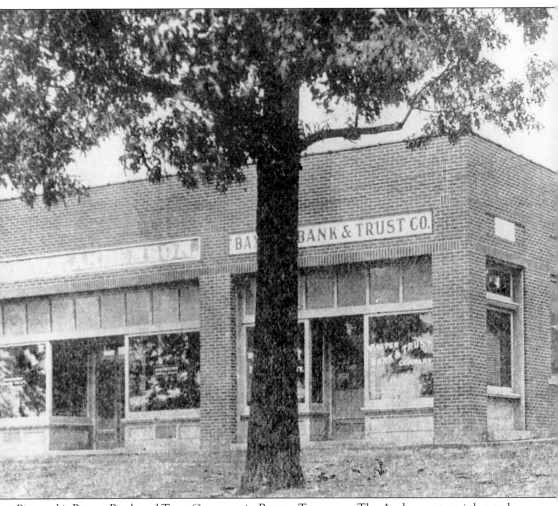

Pictured is Baxter Bank and Trust Company in Baxter, Tennessee. The Anderson store is located next door.

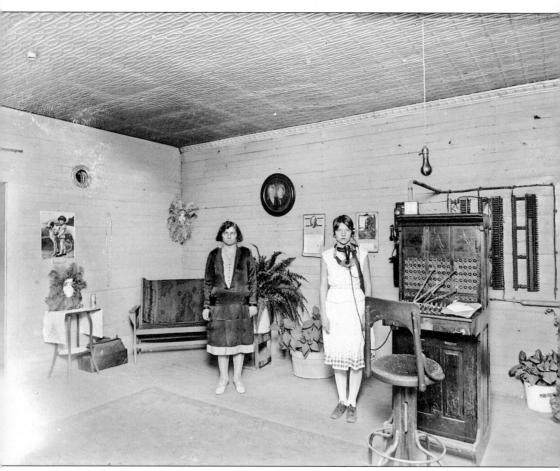

Shown here is the interior of the old Baxter Telephone Exchange Company. The two telephone operators posing are Mrs. Lynch and her daughter Josie Lynch. This photograph was taken in 1930.

Five

HOUSES AND LANDMARKS

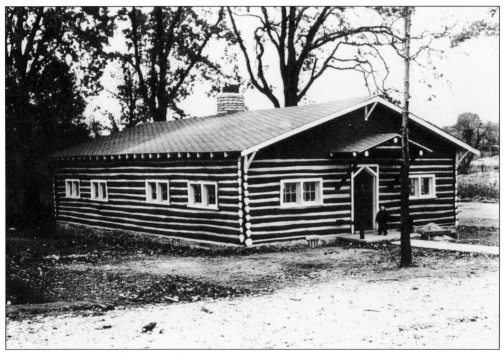

The log cabin pictured was used for Boy Scout meetings in the early 1940s and 1950s and was constructed in the 1930s by the Works Progress Administration. The building was located on Reagan Street between Dixie Avenue and Walnut Avenue. Reagan Street being on a dead-end made the cabin perfect for scout functions. Athletic activities and outdoor events took place in the large field just west of the building. It was next to the location of the second town spring that dried up due to excavation in the area.

This house is located on North Washington Avenue and is believed to be the first brick home built in Cookeville. Rutledge Smith built the house in the early 1900s, and his family lived here for many years. It was also the home Dr. and Mrs. William A. Howard. The house is currently occupied.

This house was located on the northwest corner of Dixie and Broad Street. It belonged to Mr. and Mrs. James A. Carlen. Pictured are Minerva Carlen and Addie Collier, wife of Frank Collier. It is now the First Presbyterian Church parking lot.

The Jeremiah Whitson home on North Dixie Avenue, just north of East Broad Street, was built around 1900. Notice the town spring in the foreground.

Pictured is the Robert Byrd Capshaw home, located on East Broad Street where the Putnam County Library now stands. Capshaw School is named for this same family. The Charles Vaughn family lived there for several years and operated the Vaughn's Monument Works from that location.

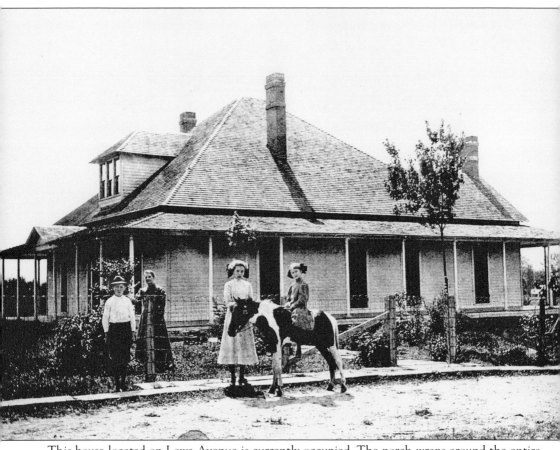

This house located on Lowe Avenue is currently occupied. The porch wraps around the entire house. It was said that the house was built with a wraparound porch so Mrs. Lowe could get fresh air without getting her feet wet. Pictured from left to right are Morrison Lowe, Lucy Cummins Lowe (wife of Gideon Lowe), Mary Lowe Jared, and Janie Lowe Paschal. The pony's name is Dan.

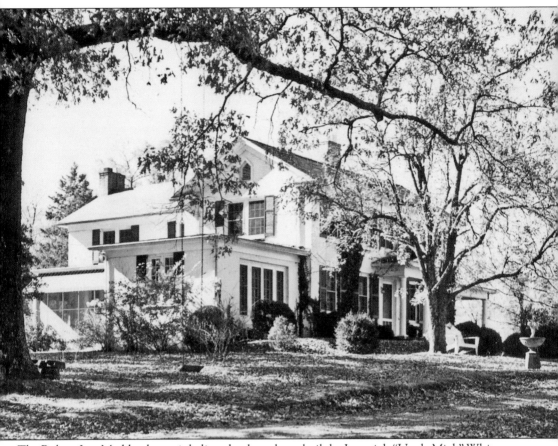

The Robert Lee Maddux home is believed to have been built by Jeremiah "Uncle Miah" Whitson in 1850. Bob Lee bought the house in 1927 and remodeled it in 1928. The columns that are on the front presently were added later. He was an avid foxhunter and was very involved in the Fox Hunters Association among other community organizations. He started Maddux, Proffitt, and Hutcheson Dry Goods, which stayed in business until recent years.

The Cronk house stood on a 250-acre farm located across from the Plateau Mental Health Center. Joe Cronk and his wife, Effie, lived there with their 12 children until the late 1940s. (Courtesy of Joyce Cronk Joseph.)

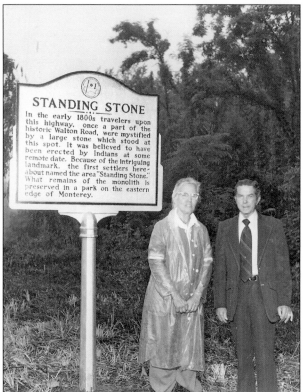

STANDING STONE

In the early 1800s travelers upon this highway, once a part of the historic Walton Road, were mystified by a large stone which stood at this spot. It was believed to have been erected by Indians at some remote date. Because of the intriguing landmark, the first settlers here about named the area "Standing Stone." What remains of the monolith is preserved in a park on the eastern edge of Monterey.

Dollie Smith Williams and W. H. Wiggins Jr., mayor of Monterey, are shown standing beside a historical marker noting the original site of Standing Stone in Monterey. The marker is on Woodcliff Road. Mayor Wiggins's father was postmaster at Standing Stone, and Dollie's father, Rutledge Smith, was a member of a fraternal group called Order of the Redmen of Tennessee, whose sole purpose was the preservation of the stone.

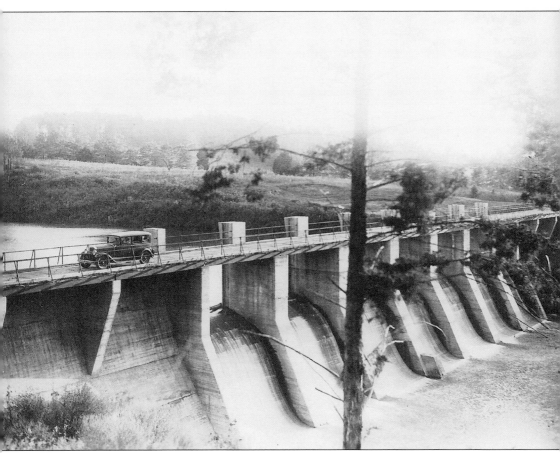

A dam creating the lake at Burgess Falls was built in 1924 upstream from the falls in conjunction with the construction of an electric power plant. That first dam washed away in the flood of 1928, and another one was built within a year.

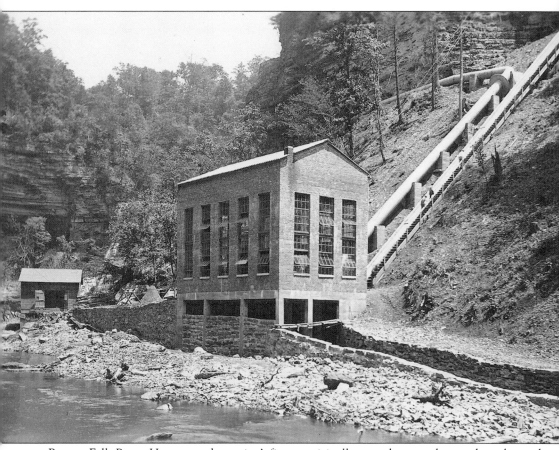

Burgess Falls Power House was the nation's first municipally owned power plant and was located in Putnam County at the foot of the bluffs at Burgess Falls. It supplied power to Cookeville from 1922 to 1944, during which time the city started purchasing power from the Tennessee Valley Authority.

Pictured here is the Burgess Falls Power House under construction. (Courtesy of Walter Hill Carlen.)

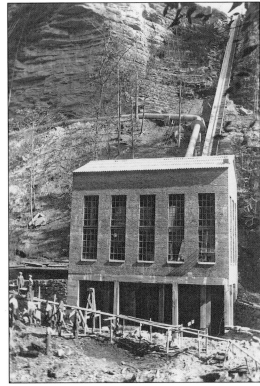

This photograph shows the Tennessee Central Railroad Bridge at Buffalo Valley, Tennessee.

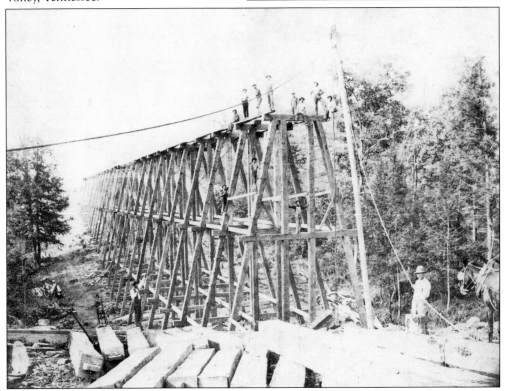

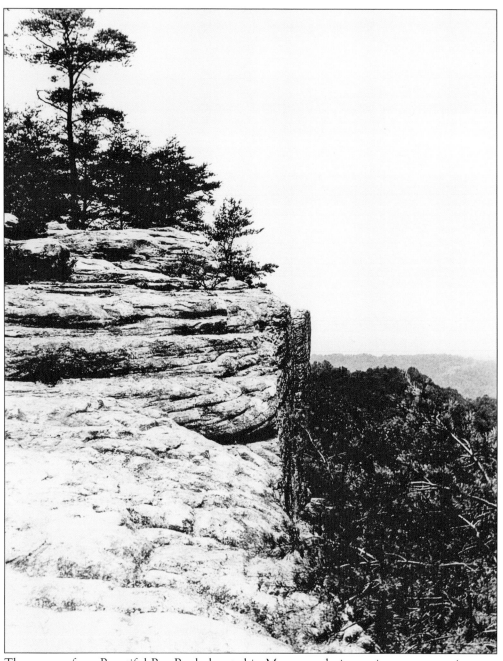

The scenery from Beautiful Bee Rock, located in Monterey, during spring, summer, winter, or fall is unforgettable.

Six

CHURCHES AND SCHOOLS

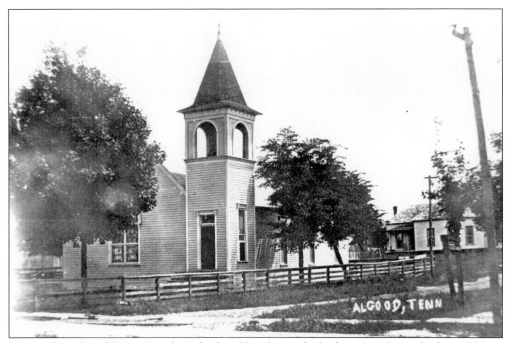

Here is the Algood First United Methodist Church as it looked in 1918. It was built in 1899 on land donated by Alfred and Henry Algood and is located across the street from the Algood Post Office. The church is on the National Register of Historic Places. In 1909, a massive twister caused the church to lean heavily to one side, but restoration efforts straightened the walls.

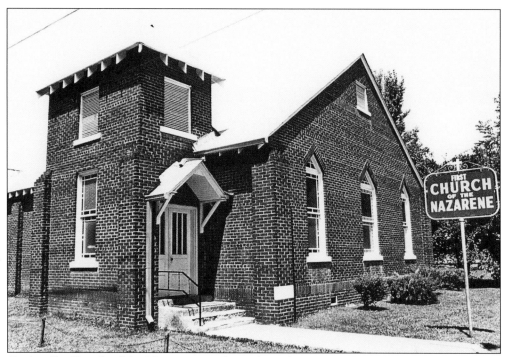

Cookeville Church of the Nazarene was located on the corner of North Walnut Avenue and Mahler Street and was built in 1927. A new church was erected on Old Kentucky Road.

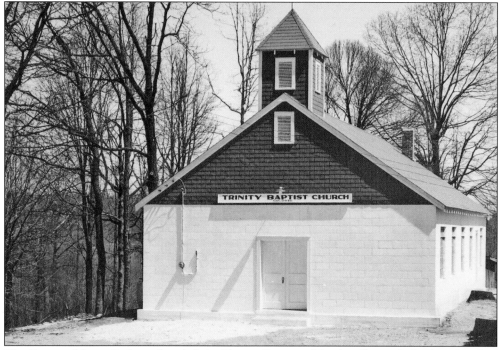

The Reverend Leroy Jackson founded the Trinity Baptist of Cookeville in 1945. This church is still a house of worship and is located on West Broad Street. In 1952, the log cabin structure was rebuilt. This is one of the oldest African American churches in Cookeville.

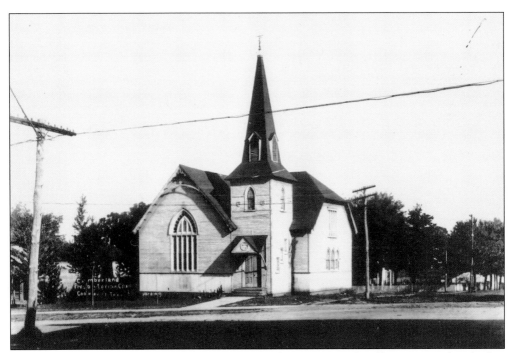

In 1856, the Cumberland Presbyterians were worshiping in Cookeville. In 1861, they built a church on East Broad Street where the First United Methodist Church's Christian Life Center is located. They later built a new church on East Tenth Street.

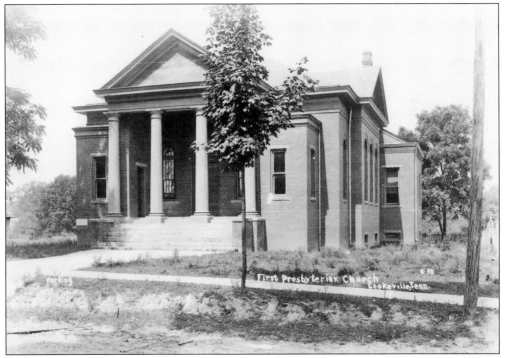

The First Presbyterian Church was built in 1910, and an addition was added to the rear of the church in 1950. It is located on North Dixie Avenue.

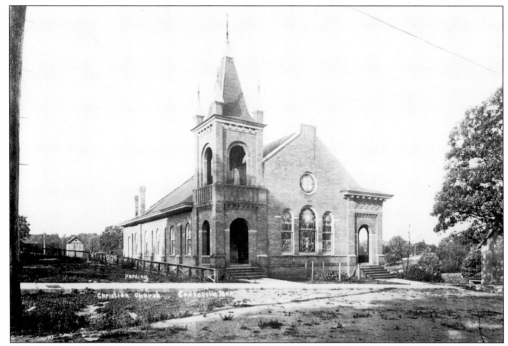

Broad Street Church of Christ was constructed in 1918 and was replaced with a new church building on South Jefferson Avenue. Owned by the First United Methodist Church, the building still exists and is used for church functions.

The Collegeside Church of Christ held its first worship service in this building on September 6, 1953. It is located on the corner of East Ninth and Tenth Streets and is very near Tennessee Technological University by design, so it could serve as a convenient place of worship for students and faculty members.

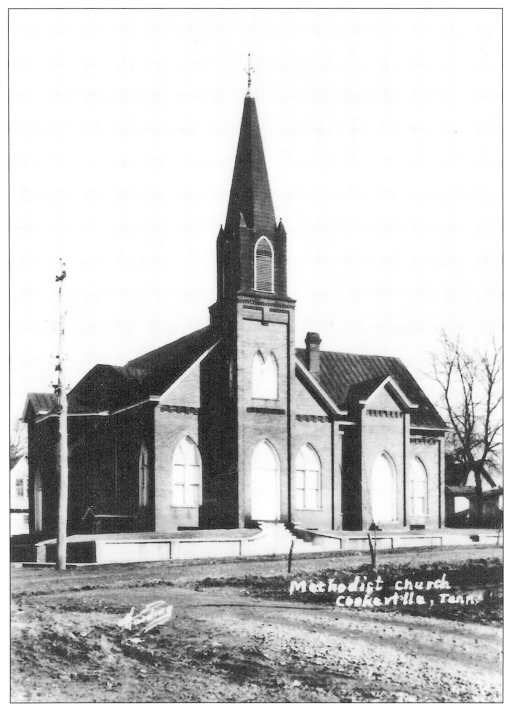

In the early part of 1857, the Methodists used a small frame building that doubled as a courthouse prior to the erection of their church building. The Baptists and Presbyterians also used this early structure. As the church membership grew, construction began on a one-room brick structure located on the corner of North Dixie Avenue and Spring Street. The present building was first used in 1950. The 1910 building was removed to make way for the erection of the sanctuary.

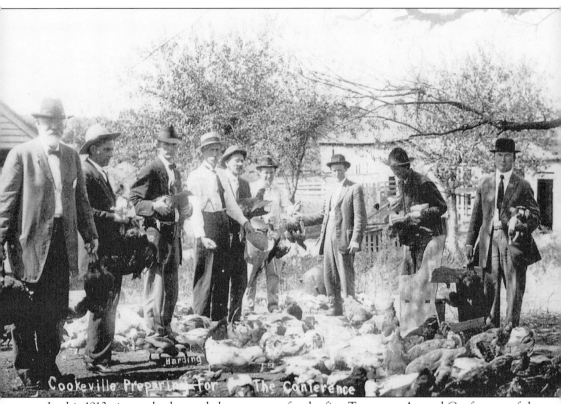

In this 1913 picture, leaders and clergy prepare for the first Tennessee Annual Conference of the Methodist Church in Cookeville. The picture is believed to be taken at what was then the Stacy Wilhite home on Dixie Avenue, which is now known as the Fred and Mary Della (Pointer) Roberson home. Pictured from left to right are Jere Whitson, Oscar King Holladay, L. M. Bullington, John Chilcutt, Rev. W. W. Baxter, Willie Holladay, Rev. W. M. McClearen, unidentified, and J. N. Cox. (*Putnam County Herald*, August 1955.)

St. Thomas Aquinas Catholic Church is located on the corner of Sixth Street and North Washington Avenue. Built in 1950, it was replaced with a new building in 2006. Before there was a building, mass was offered in the W. P. Morris home, and later, when the parish grew, arrangements were made to use the first-floor room of the Shanks Hotel located on the west side of Cookeville. Later a large basement room of the John Moran family at Sixth Street and North Maple Avenue was used.

The old Algood School was a three-wing, white frame building built in 1902–1903 on Main Street on land purchased from James Thomas Pointer. It provided the educational facilities for Algood until a new school was built in 1922.

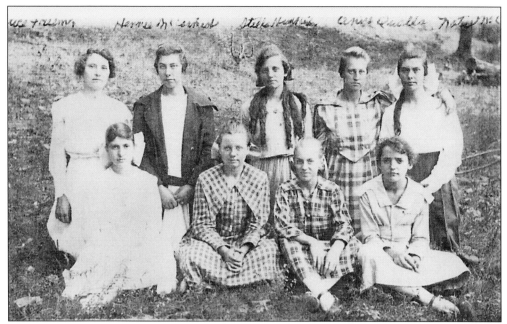

This group of girls from Algood High School has gathered for a graduation picture in 1918. Pictured from left to right are (first row) Myrtle Deck Finley, Elise Huddleston, Grace Burton Carmack, and Velma Freeman; (back row) Alice Freeman, Hennie McCormick, Stella Huddleston, Alice Qualls, and Notie McCormick.

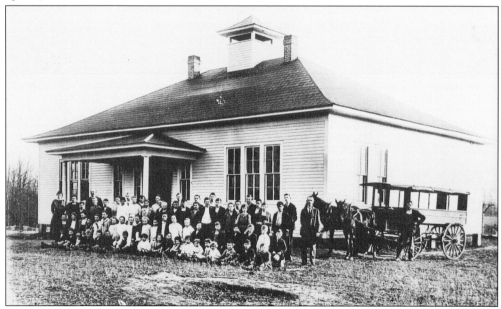

Holladay School represented two firsts for Putnam County: it was the first consolidated school and was served by the county's first school bus. The first school was constructed in 1915, formed from Lee Seminary, Lone Oak, and Pleasant Valley Schools. The school was named for Judge Oscar Holladay, one of the three men most responsible for its existence, along with Harvey McCully and Monroe Hatfield. Three enclosed wagons pulled by horses were used as school buses. The school closed in the mid-1960s. It is now the home of Dr. Sam and Shelia Barnes.

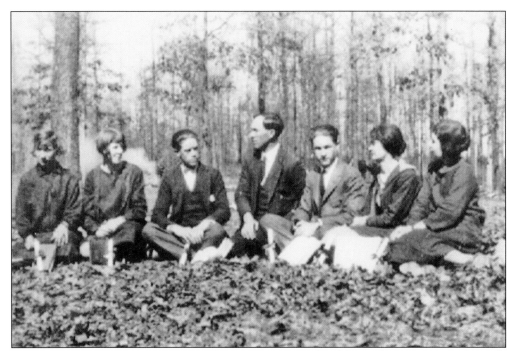

Pictured are eighth-grade graduates of the Oak Grove School located near Baxter. The only identified students of the class of 1922 are Norma Cronk, second farthest from the left, and Edna Stewart, to Norma's left. Oliver Bussell was the teacher and is in the center of the group. The rest are unidentified. (Courtesy of Joyce Cronk Joseph.)

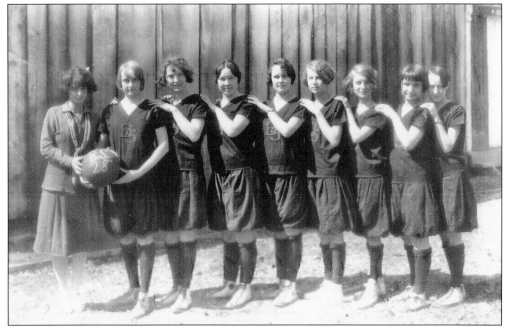

This is a photograph of the Baxter Seminary basketball team. Dr. Henry L. Upperman founded the school and served as its president for 34 years from 1923 until 1957. The school was a Methodist coeducational secondary school and served the Upper Cumberland region of Tennessee.

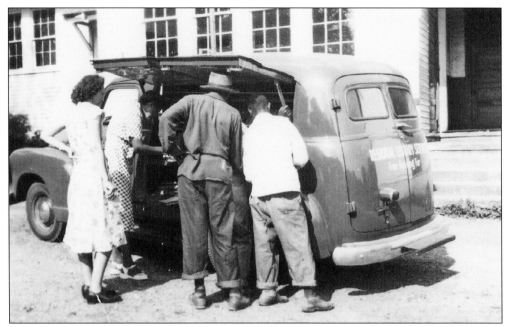

This photograph shows the Darwin School Book Mobile. The Darwin High School's first graduating class was in 1938. The school was built in 1928 as West Side Junior High School, and in 1936, a senior high school department was added. The school was renamed in honor of J. Claude Darwin, a Cookeville merchant who promoted African American high school education. It catered to the educational needs of surrounding counties, including Overton, Clay, and White. Isaac Bohannon, a graduate of the first senior class, became principal in 1952. A fire destroyed the school on January 8, 1963, and destroyed all student performance records.

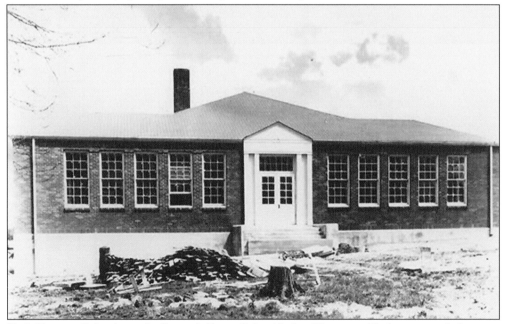

Tech Training School was the Seventh Street School before Tennessee Tech was awarded a grant to remodel and use the elementary school as a training school for teachers in 1949.

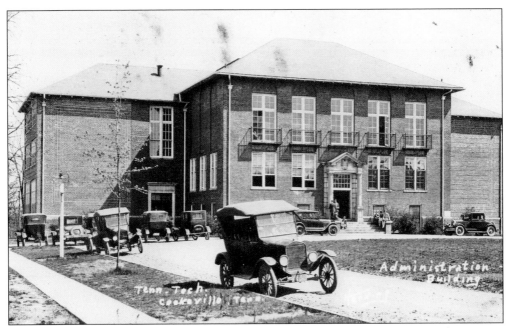

Shown here is a very early photograph of Dixie College, which was the forerunner of Tennessee Polytechnic Institute, later to become Tennessee Technological University. It was chartered in November 1909, and construction began in May 1911 on 12 acres of donated land.

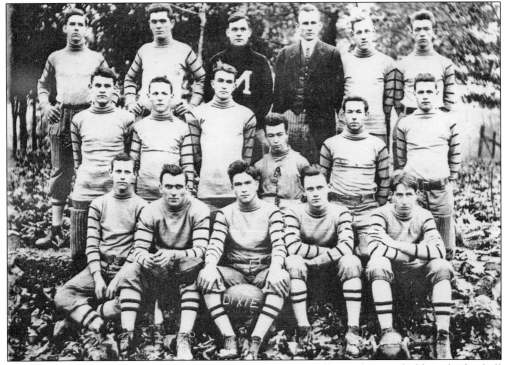

This 1912 photograph shows the first football team at Dixie College. The man holding the football is Ralph Jared from Cookeville and Buffalo Valley. According to his wife, Mary Lowe Jared, he scored the first touchdown at Dixie College. (Photograph courtesy of Lucy Stanton.)

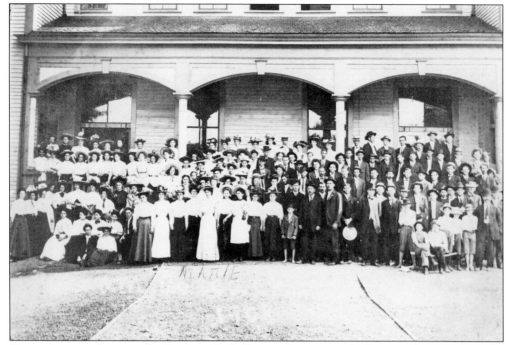

Pictured are students at the Cookeville Collegiate Institute, which opened in 1901 on the site of the old Washington Academy. It was located on East Broad Street where the city hall presently stands.

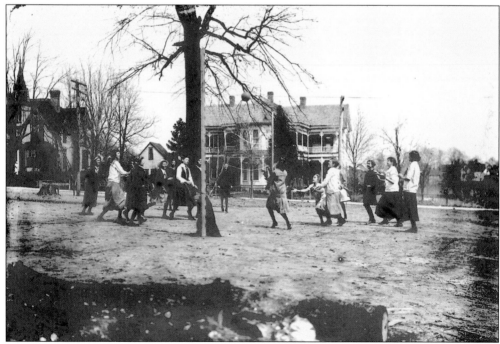

This photograph of a group of students playing volleyball in the front yard of the old Cookeville City School was taken around 1920. In the background, the Henry Martin home stands to the left, and the Robert Capshaw house is on the right.

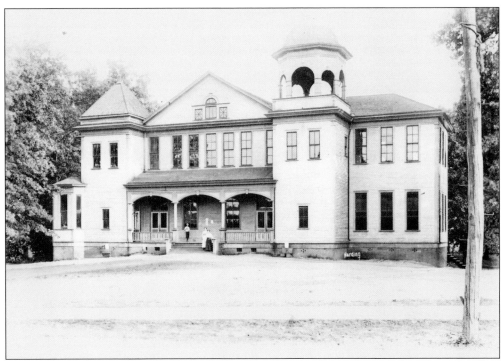

This photograph is of the Cookeville Collegiate Institute, which later became Washington Academy. It was eventually replaced with the old Cookeville City School on the land where the city hall is now located.

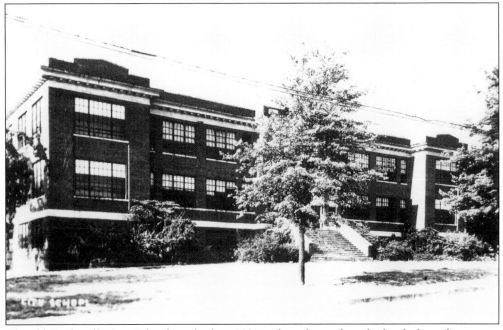

The old Cookeville City School was built in 1921 and was located on the land where the present city municipal building stands at 45 East Broad Street.

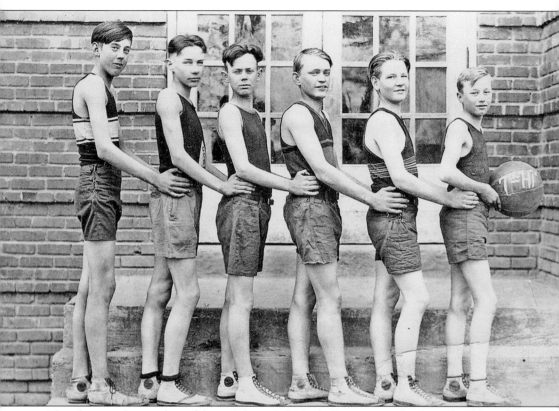

This photograph was taken of the eighth-grade basketball team around 1921 at the old Cookeville City School. Pictured from left to right are Claude Rich, Claude Haile, Allison Richardson, Walter Dobbs, Lloyd Fox, and Walter Rhea Carlen.

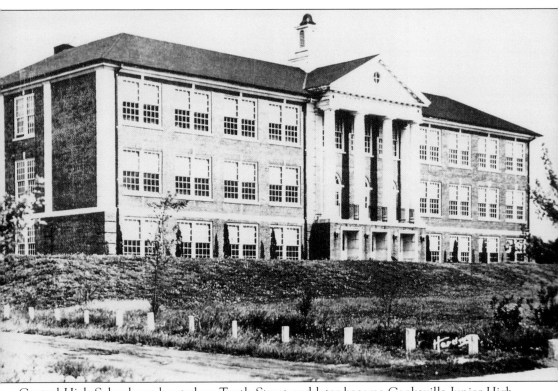

Central High School was located on Tenth Street and later became Cookeville Junior High School. It is now the Prescott Middle School.

Shown here from left to right are three Central High School teachers in the 1950s: Pauline Hudgens, Mary Barbour, and Shelia Officer. Hudgens was an English teacher, Barbour was a librarian, and Officer was an English teacher but was very effective in promoting theater to students in the Putnam County School system. She directed plays such as *The Glass Menagerie*.

Seven

MILITARY AND PROFESSIONAL

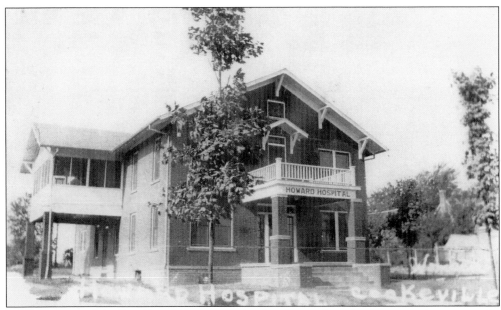

Howard Hospital on East Broad Street was the first hospital in the county and was open for patients in 1923, with Dr. Howard as the surgeon in charge. Before the opening, patients had to take the train, and many died on the way. Dr. Howard knew it would lose money but saw the need. The brick structure accommodated 15 patients a day. The city bought the hospital in 1927 for $18,000 and started operating it. City commissioners elected the first hospital board of trustees. They were chairman Jere Whitson, secretary Walter R. Carlen, D. C. Wilhite, L. D. Bockman, Robert L. Farley, W. C. Davis, H. J. Shanks, J. A. Butler, J. Thomas Moore, Zebedee L. Shipley, William A. Howard, Lex Dyer, C. P. Martin, J. R. Stone, and H. C. Martin. The staff physicians were Dr. W. A. Howard, Dr. Harland Taylor, and Dr. J. T. Moore. The nurses were Rena Keathley and Kate Smith. The cafeteria was known for its wonderful food.

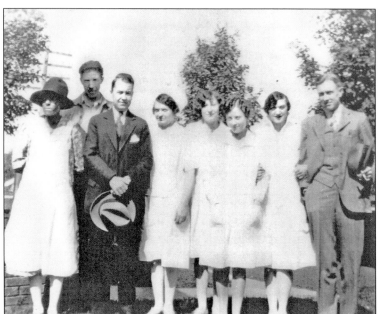

Shown here is the staff at Howard Hospital. The only people identified in the picture are Dr. W. A. Howard and Dr. T. Moore.

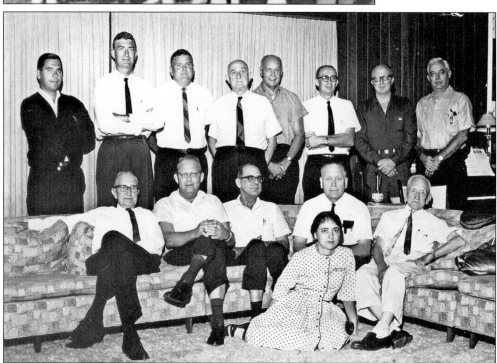

This picture of local Cookeville doctors was taken in 1965 at the home of Dr. J. T. DeBerry on North Washington Avenue. Pictured from left to right are (seated on the floor) Dr. Katherine Crawford Wolfe; (on the sofa) Dr. W. A. Howard, Dr. William A. Hensley, Dr. Jack Clark, Dr. Thurman Shipley, and Dr. Tom Moore; (standing) Dr. William S. Taylor, Dr. Jere Lowe, Dr. Claude Williams, Dr. Fred Teny, Dr. Robert Larrick, Dr. Clarence L. Jones, Dr. J. T. DeBerry, and Dr. Kenneth L. Haile. The other two Cookeville doctors who were on duty at the hospital were Dr. Jack Moore and Dr. Bill Francis. (Courtesy of Dr. John Limbacher.)

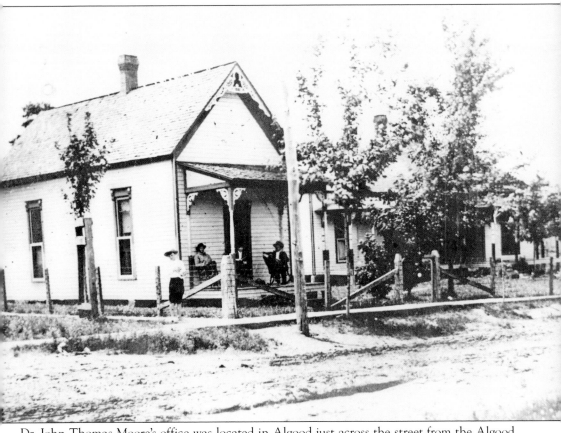

Dr. John Thomas Moore's office was located in Algood just across the street from the Algood First United Methodist Church. Dr. Tom, as he was affectionately known, was the son of Thomas Franklin Moore and Bettie Fraser, who had nine children. They lived in an area of Putnam County called Calfkiller. Bettie organized the first Methodist church in the Calfkiller area. Dr. Tom completed his medical training in 1899 and treated people in their homes, arriving on horseback or in a horse-drawn buggy. His son, Dr. Jack Moore, was a practicing physician in Putnam County for many years, and his grandson, Dr. Lee Moore, is a practicing physician in Cookeville today.

Dr. Henry Algood, brother to Alfred Algood, who once served as an attorney general, was the son of early pioneer Joel Algood for whom the town of Algood was named. Dr. Algood was a noted pharmacist and doctor in the early days. Dr. Henry and his wife, Francis Crutcher Algood, sister of Mrs. Lillie Josephine Burton and Mrs. Lillie Martin, were very involved in the community. Lillie Martin gave birth to the first baby born in Cookeville.

James William Jared (1841–1919) joined the Confederate Army at Camp Zollicoffer in Tennessee. There he was ranked second lieutenant. Jared, later shot in the shoulder at Shiloh, fought at Egypt Station in Mississippi, where he was shot in the hip. His regiment surrendered and was paroled in 1865 in Greensboro, North Carolina. Jared refused to take the oath of allegiance in order to be paroled. He later returned to Tennessee where he lived. Jared was the son of Samuel Raulston and Mary Scruggs Jared.

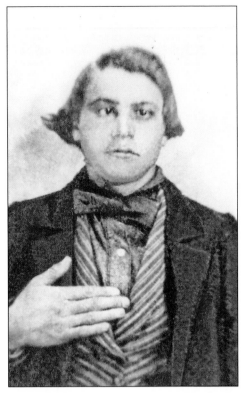

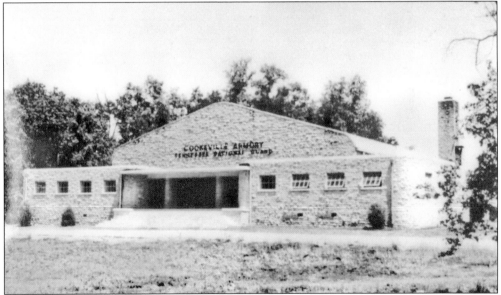

During World War I, many servicemen trained for combat in Putnam County. In 1943, Tennessee Polytechnic Institute (now Tennessee Technological University) taught around 2,000 Army Air Force cadets every year in a four-month academic session, which was preceded by their flight training. The state constructed the National Guard Armory at this time on March 27, 1942, on US 70 North at East Spring Street. The building still exists and has been used for various things. Currently it is the adult high school.

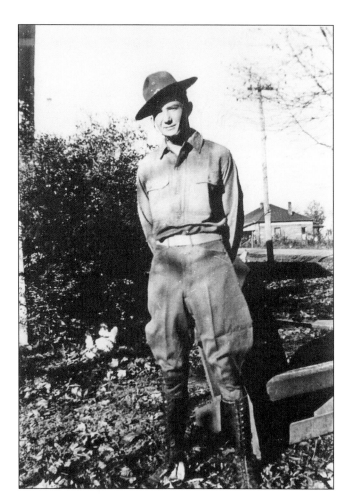

Pictured in 1938 is Hubert W. Bussell in his horse cavalry uniform. The cavalry offered young men who loved horses a chance to show them in local parades, ceremonies, and display drills. Cavalry members rode in military funerals and helped the state police when needed. There were annual encampments in Georgia, Mississippi, and Louisiana.

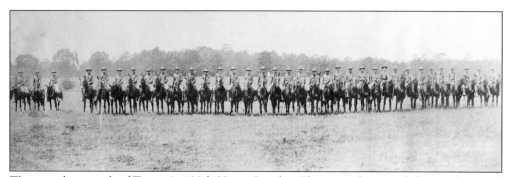

This is a photograph of Troop A, 109th Horse Cavalry. The men who joined the cavalry guard signed for three-year enlistments. They had monthly Sunday morning drills, which included rifle and pistol practice, mounted drill, dismounted drill, and classroom work. The session lasted about three hours, and those who attended church could attend an 11:00 a.m. service.

These three men represent members of the Cookeville National Guard. They often used the cavalry barn for training. Pictured here from left to right are John Mitchell, Quinten M. Smith, and James Quarles.

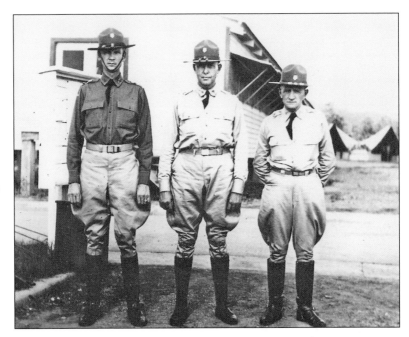

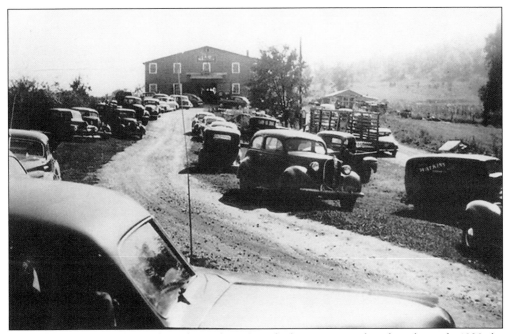

The old cavalry barn located on the Hubert Crawford property, replaced in the early 1930s by a new building, was sold in 1948. This picture is a glimpse of a building that was important to the 109th cavalry. At first, the troops conducted training in the basement of the Terry Brothers building, located on the town square, and drilled on the streets nearby. At Camp Walton, as it became known, the men had ample room for training and participated in drills on one Sunday of each month. The old barn was located on East Spring Street next to what is now Johnson's Nursery and Garden Center.

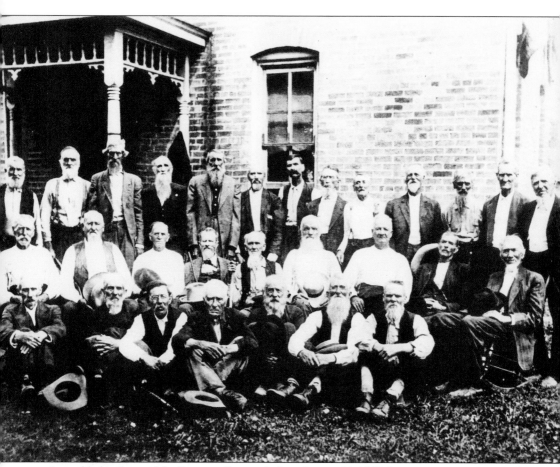

Assembled in front of the Putnam County Jail on August 24, 1912, for a group portrait were these Confederate veterans of the Civil War from around the area of Putnam County. Pictured from left to right are (first row) Mansfield Whitson, James Thompson, unidentified, John Farris, Dr. Lemuel R. McClain, unidentified, and Jim Nickles; (second row) Hick Buck, Joe Hudgens, Jacob Davis, John Quails, Mack Wilhite, John Maybeny, Jackson Davis, Robert Alcorn, and Joe Dyer; (third row) Bob Stewart, Milton Owens, Brack Quails, Newton Rurk, Charles Bradford, Hugh Terry, Alex Weeks, Amos Williams, unidentified, Lafayette Siiger, Will Cumby, Nelson Hyder, and Dolph Watson.

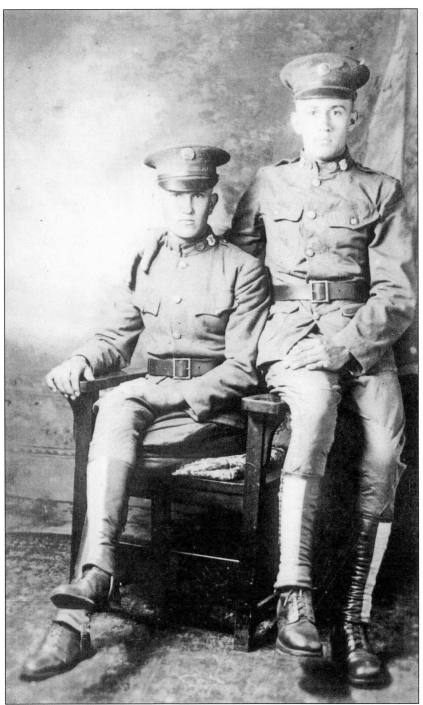

Pictured are Oscar Freeman Howard (seated in chair) and an unidentified friend around 1925. Major Howard was born in Welch Hollow near Monterey in Putnam County. His parents were Zemery and Rosa Ann Neal Howard. His sisters were Celia, Nellie, and Tess, and his brothers were Rastus, Jake, and Lawrence Howard. He was a veteran of World War I and World War II and retired from the army with the rank of major.

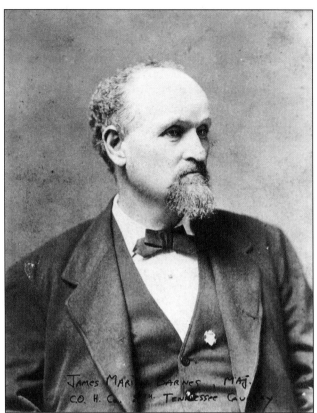

James Marion Barnes (1830–1886) was the seventh son of original settler Thomas Barnes (1797–1851) of Dry Valley. James was encouraged to resign his cadetship at West Point because of his involvement in a duel. He commanded H Company 8th Tennessee Cavalry (Dibrell) C.S.A. He was a partner of Buck and Barnes Foundry in Nashville. He is buried in Mt. Olivet Cemetery. His widow was Sarah Jane (Sallie) Buck.

This is a picture of a Civil War veteran taken in 1910. The location is not known but it is believed to be in the Buffalo Valley area or along Walton Road. Notice the rock wall in the background.

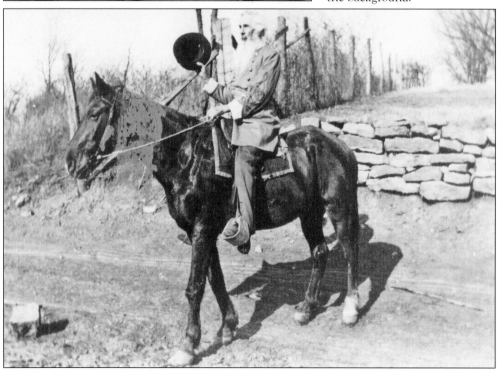

Eight

TRANSPORTATION

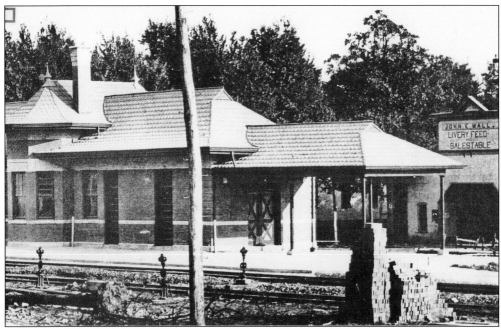

In the early 1880s, Alexander Crawford, a Pennsylvania iron manufacturer, was intent on extracting coal in this area, so he obtained the rights to thousands of acres in Fentress and Putnam Counties. The Tennessee Central Railroad constructed the Cookeville Depot in 1909. It was located across the street from Duke Hotel. When the railroad came in 1890, it made Cookeville into a town of the future and changed the Upper Cumberland region forever. Some of that history is preserved today in the Cookeville Depot Museum. It is still the same building and was placed on the National Register of Historic Places in 1985.

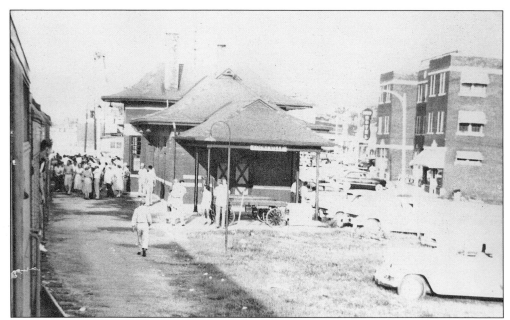

This 1940s photograph shows passengers boarding the Tennessee Central Railroad at the Cookeville Depot. There appears to be military men also boarding. Over to the right is the Shanks Hotel. The coming of the railroad to Cookeville definitely started a new era, establishing new communities such as Buffalo Valley, Silver Point, Boma, Double Springs, Baxter, Algood, Brotherton, and Monterey as well as new businesses.

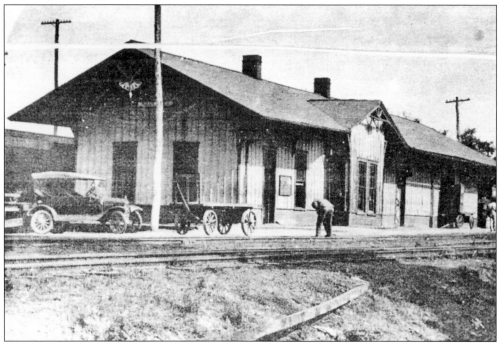

The Monterey Tennessee Central Depot was constructed in 1902, after the old depot burned the same year. Excursion trains brought tourists into town to enjoy the cool mountain air and stay in one of the many lovely resort hotels in Monterey.

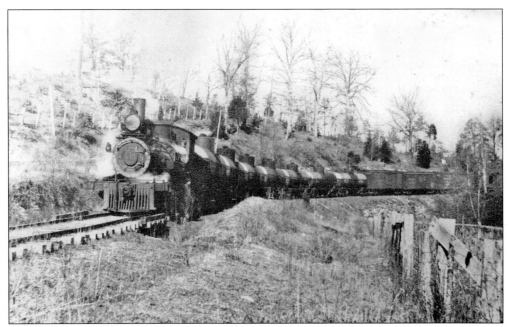

By the early 1900s, six passenger trains a day rolled across the Upper Cumberland region, and new towns such as Baxter, Buffalo Valley, Boma, Double Springs, Algood, and Monterey were created. By 1904, the Tennessee Central stretched 251 miles from Hopkinsville, Kentucky, through Nashville to Harriman. Because its economy was tied to rails, the true railroad town of the region was Monterey. The rail companies built depots along the route.

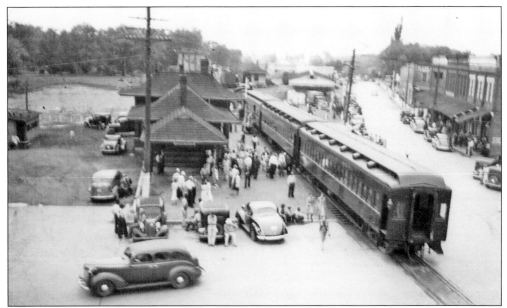

Military men and passengers lined up at the Cookeville Depot to board a Tennessee Central passenger train rolling out of Cookeville in July 1955. The railroad reached its peak in the 1940s. Facing east, the Shanks Hotel is visible in the upper right-hand corner.

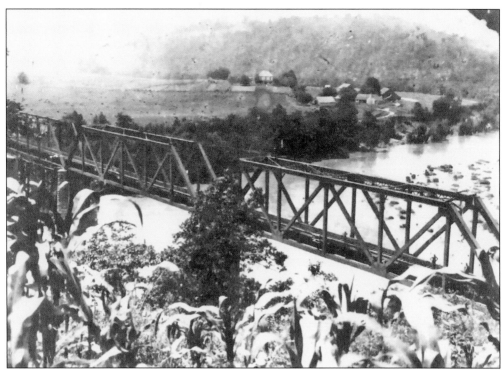

This was the Buffalo Valley Railroad Bridge in 1912.

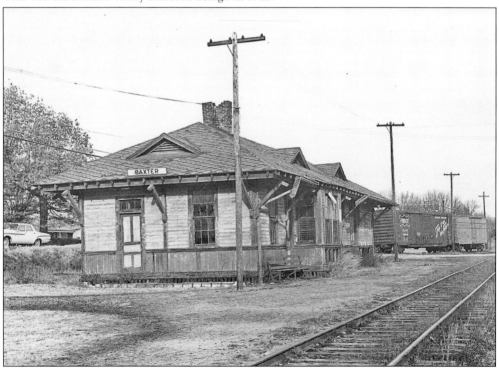

Here is the Baxter Depot. With the coming of the railroad to Cookeville, all communities benefited, and soon the Tennessee Central Railroad built depot buildings all along the line.

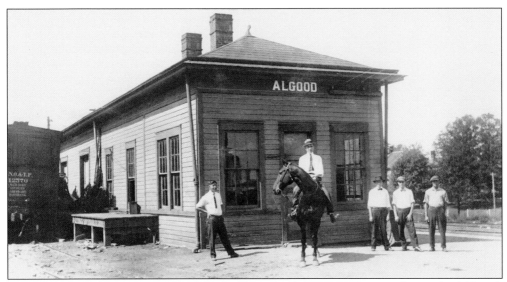

Algood Depot received all mail for Algood and surrounding communities to the north of Algood. After the mail was received, it was delivered by pushcart to the appropriate post office. The mail for Rickman, Livingston, and other points to the north was unloaded on the back of a covered truck and then transported to the other locations. The vehicle was referred to as the mail hack as it also carried passengers. The Algood Depot was most important to the town of Algood.

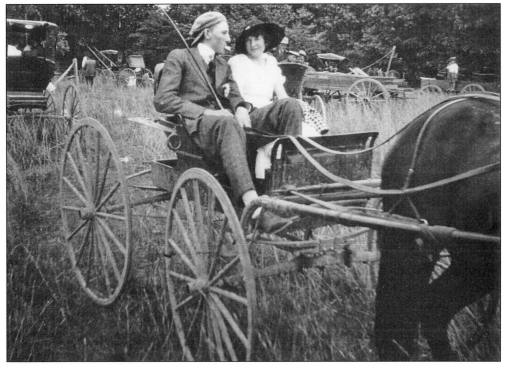

This photograph was taken of a couple taking perhaps a Sunday afternoon ride with other couples. Wagons were not just for pleasure but there were work-type wagons to carry goods. They wound slowly down the steep, narrow roads, which were muddy in the winter and rough in the summer.

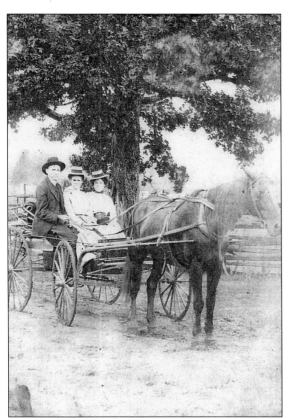

This family is perhaps going to church on a Sunday morning. Before the railroad came, wagons and river transport were the only two ways to go anywhere.

Myrtle Hurst Barnes (1877–1952), wife of Jesse Crockett Barnes, is seen in this car in 1918. All the other passengers are her children. From left to right they are Mable Broshear, Allen Broshear, Alice Broshear, Jessie Barnes, and Frank Hurst Barnes. Myrtle was active in the women's Republican Party of Tennessee, the Methodist church of Cookeville, the women's suffrage movement, and the Eastern Star.

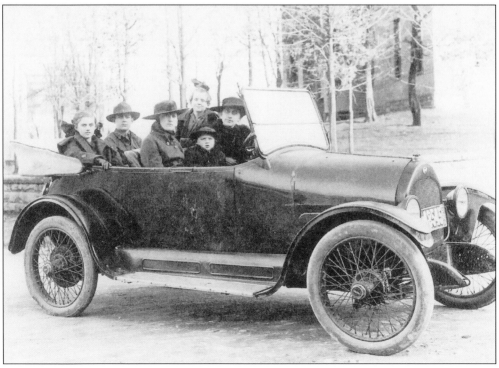

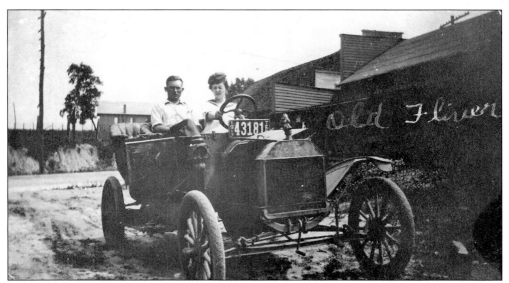

This flivver was made in 1912. Driving is Lawrence Simmons and the passenger is Eula Holloway, wife of Howard Holloway.

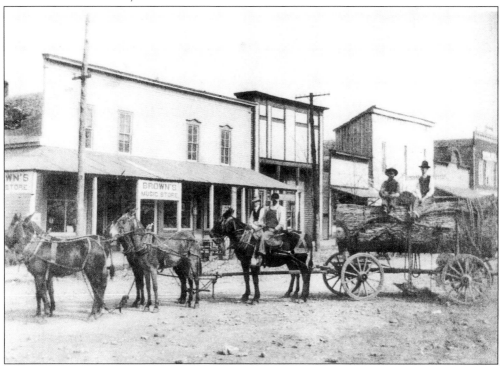

It took six mules to haul this huge log to Cookeville after it was cut from the Simp Officer Farm, which was about 5 miles southwest of Cookeville. Shown in the picture from left to right are Bedford Mills, who moved to Oklahoma to live; Eldridge Grimes, a timber cutter who lived in the Lee Seminary community; Byrd Dowell; and Blachard Duke of Nashville. Byrd Dowell was a mail carrier and owned a lot of property. This picture was taken on the north side of the courthouse square. The building on the extreme right today is the location of Will Roberson's law office. The other old buildings shown include the James Carlen Grocery Store and Brown's Music Store.

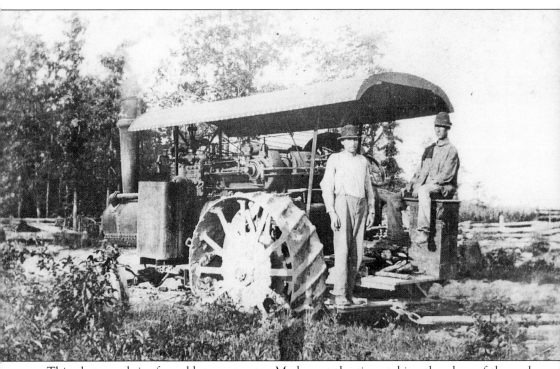

This photograph is of an old steam tractor. Modern at the time, taking the place of the mule, these tractors were used at Tennessee Polytechnic Institute and on some of the larger farms in the area.

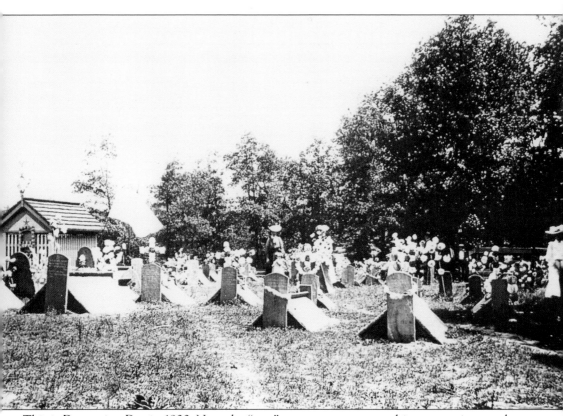

This is Decoration Day in 1900. Note the "tent" graves—cemetery architecture unique to the Upper Cumberland region. Sandstone slabs were placed between headstone and footstone to cover the grave.

www.arcadiapublishing.com

MAP SEARCH

Discover books about the town where you grew up, the cities where your friends and families live, the town where your parents met, or even that retirement spot you've been dreaming about. Our Web site provides history lovers with exclusive deals, advanced notification about new titles, e-mail alerts of author events, and much more.

MADE IN THE

USA

Arcadia Publishing, the leading local history publisher in the United States, is committed to making history accessible and meaningful through publishing books that celebrate and preserve the heritage of America's people and places. Consistent with our mission to preserve history on a local level, this book was printed in South Carolina on American-made paper and manufactured entirely in the United States.

This book carries the accredited Forest Stewardship Council (FSC) label and is printed on 100 percent FSC-certified paper. Products carrying the FSC label are independently certified to assure consumers that they come from forests that are managed to meet the social, economic, and ecological needs of present and future generations.

FSC

Mixed Sources
Product group from well-managed forests and other controlled sources

Cert no. SW-COC-001530
www.fsc.org
© 1996 Forest Stewardship Council

Find *Your* Place in History.